RIVER MERSEY

FROM SOURCE TO SEA

Phil Page & Ian Littlechilds

AMBERLEY

FOREWORD

Over the last fifty years, when people have spoken of the River Mersey, the picture brought to mind is that associated with the famous pop song and those familiar grey, grainy images of Liverpool in the 1960s. The presentation of this narrow image is to ignore the full, rich heritage of this historic and immensely important waterway, and its place in the social and economic history of the area. I am delighted that Ian Littlechilds and Phil Page have been presented with the opportunity to record its entire length in both photographs and text.

The River Mersey holds a particular interest for me as my grandfather was born in Liverpool, near to the Mersey's course. I have lived in Stockport for many years and every few weeks go to Jon Bernhard's hairdresser's, whose shop has stood no more than a few steps from the river's source for years. To stand outside on the small bridge, looking down at the conjoining Tame and Goyt, knowing how the resulting force will widen, deepen and bend as it flows on its journey to the sea, can be a powerful reminder of its history and the people whose lives have been shaped by its influence.

The river, its history, its people, and its ever-changing beauty, are fittingly celebrated in this book.

Dame Kathryn August

First published 2014

Amberley Publishing
The Hill, Stroud, Gloucestershire, GL5 4EP
www.amberley-books.com

Copyright © Phil Page & Ian Littlechilds, 2014

The right of Phil Page & Ian Littlechilds to be identified as the Authors of this work has been asserted in accordance with the Copyrights, Designs and Patents Act 1988.

ISBN 978 1 4456 3310 7 (print)
ISBN 978 1 4456 3327 5 (ebook)

All rights reserved. No part of this book may be reprinted or reproduced or utilised in any form or by any electronic, mechanical or other means, now known or hereafter invented, including photocopying and recording, or in any information storage or retrieval system, without the permission in writing from the Publishers.

British Library Cataloguing in Publication Data.
A catalogue record for this book is available from the British Library.

Typesetting by Amberley Publishing.
Printed in Great Britain.

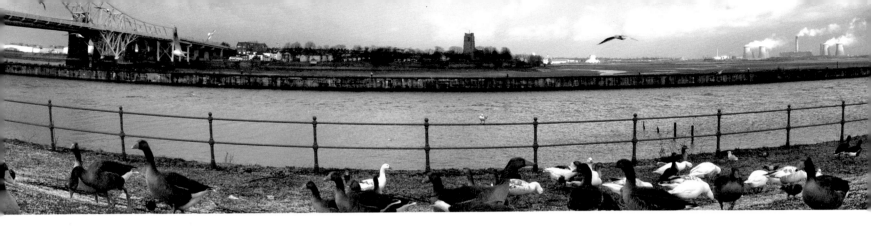

CONTENTS

THE MERSEY SOUND

The most recognisable song about the River Mersey was produced by George Martin and reached number 8 in the charts for Gerry and the Pacemakers in 1965. 'Ferry Cross the Mersey' helped to forever link the river with Liverpool and the Mersey scene, securing its iconic place in the popular culture of the twentieth century. But other areas along the river have also contributed to the river's musical history over the years.

In the early 1960s, the *Top of the Pops* studio opened in a disused church at Dickenson Road, Rusholme, a few miles north of the river's source and, in 1968, Strawberry Studios, named in honour of The Beatles' famous song, opened in Stockport producing the work of a number of internationally popular artists, including The Smiths and Paul McCartney.

Some three miles along the river, Didsbury had its own centre of popular entertainment at its ABC Studios. On Monday 14 May 1964, Bob Dylan made his first live television appearance in the UK, playing songs such as 'Chimes of Freedom' and 'Don't Think Twice It's All Right'. On 7 September 1963, The Beatles recorded three songs for ABC's *Big Night Out*; one of their early UK television appearances.

In nearby Chorlton, the Gibb brothers spent nearly five years of their childhood living at No. 51 Keppel Road, before moving to Australia in 1958. Legend has it that on a Saturday afternoon in 1955, they picked out an Everly Brothers record and headed off to a local cinema to lip-sync to the record before the film. Apparently, the record got damaged on the way and the Gibb boys had to sing another song in front of their first live audience. From small beginnings they went on to provide decades of chart hits including 'Night Fever' and 'Stayin' Alive'.

After passing through Sale and Ashton-on-Mersey, the river touches the southern border of Urmston. On Monday 5 August 1963, the council had booked The Beatles to play at the Urmston Show at Abbotsfield Park. At the time of the booking, they were not well known, but by the time of the concert, they had hit the top of the UK charts with their first No. 1 'From Me to You'. The group honoured the booking and had to be smuggled into the venue in the back of a van while screaming girls tried to rush the stage inside. The band were paid 10 guineas appearance money. To mark the fiftieth anniversary, the town planned a huge celebration concert hosted by David Hamilton, who was compére at the original show.

Moving along to Warrington, in 1985, local resident and record producer Pete Waterman discovered one of his biggest stars, Rick Astley, performing as a drummer with a local soul band named FBI. By 1987, Astley was one of the biggest stars of the decade with his debut single, 'Never Gonna Give You Up', becoming the year's biggest seller.

In 1965, young aspiring folk musician Paul Simon was playing the pubs and clubs of South Lancashire and North Cheshire. After a performance at a folk club in Widnes, and a being afforded a bed for the night in a house in Coroner's Lane near the station, Paul headed off the next morning to Widnes station where, legend has it, he wrote down some, or all, of the ideas

for 'Homeward Bound'. A brass plaque in the station's waiting room commemorates the event.

Widnes does have its own confirmed piece of popular music history. On May 1990, some 27,000 fans descended on the town to attend the legendary concert by the Manchester band The Stone Roses at nearby Spike Island.

Despite the Wirral being on the opposite side of the river from the accepted Mersey Scene, several famous bands and artists have done their best to make their mark on Mersey musical history, including Miles Kane, Elvis Costello, The Boo Radleys, Half Man Half Biscuit, and Orchestral Manoeuvres in the Dark.

Established in 1989, and held each November across the Wirral, the International Guitar Festival of Great Britain is an annual celebration of the guitar and its music, and presents world-class performers from across the globe performing the widest range of musical styles, including blues, jazz, classical, rock, country, flamenco, pedal steel and slide. The events take place in venues, which include concert halls, arts centres, Birkenhead Priory, local bars and the Mersey ferries.

Across the water, in Mathew Street, is the place where the 'Four Lads Who Shook The Wirral' started it all, but more of them when we reach the river's end.

Strawberry Studios stands on Waterloo Street in Stockport, a short stroll from the river.

The Capitol Theatre in Didsbury was used by ITV for a number of light entertainment broadcasts between 1956 to 1968.

INTRODUCTION

The River Mersey was the ancient divide between the Saxon kingdoms of Mercia and Northumbria, the name itself originating from the Old English 'maere', meaning boundary. It has its beginnings in the town centre of Stockport, at the confluence of the River Tame and the River Goyt, and wends its way west, towards Liverpool, passing through leafy areas of South Manchester towards Warrington. It becomes tidal at Howley Weir, nearly ten miles from the sea, where the Upper Estuary starts. It continues to widen and eventually forms the Inner Estuary at Runcorn, where there is a confluence with the navigable River Weaver. It flows on to form the Outer Estuary, a large area of intertidal sand and mudbanks, and then flows into Liverpool Bay and on to the Irish Sea.

For over 250 years, the Mersey and its tributaries suffered badly from pollution and neglect. When Liverpool's first dock opened in 1715, the Mersey catchment was drawn into a huge period of industrial expansion, with many of the initial industries based on bleaching and dyeing. Printing, glass-making and other heavy chemical industries followed, all using the Mersey and local watercourses as a means of disposing chemical waste.

By 1869, the Mersey and the Irwell had become so grossly polluted that a Royal Commission on Rivers Pollution was appointed to study and report on the problem. However, little was done and even as recently as fifty years ago, the Mersey was considered one of the most polluted rivers in Europe.

By 1983, things were so bad that Sir Michael Heseltine, then Secretary of State for the Environment, was quoted as saying:

Today the river is an affront to the standards a civilised society should demand of its environment. Untreated sewage, pollutants, noxious discharges all contribute to water conditions and environmental standards that are perhaps the single most deplorable feature of this critical part of England.

Founded on Heseltine's personal initiative, the Mersey Basin Campaign was established in 1985, and received government backing for a twenty-five-year regeneration programme. Its role was to address the problems of water quality and associated landward dereliction of the River Mersey and its tributaries.

The effect of the intensive clean-up operation by the Mersey Basin Campaign can be seen through the return of a variety of wildlife along the whole length of the river.

The Mersey's key tributaries – the Goyt, Tame, Sett and Etherow – are now providing good, clean water to the river's source and, in 2009, it was announced that the river is cleaner than at any time since the Industrial Revolution. It is now considered one of the cleanest rivers in the UK.

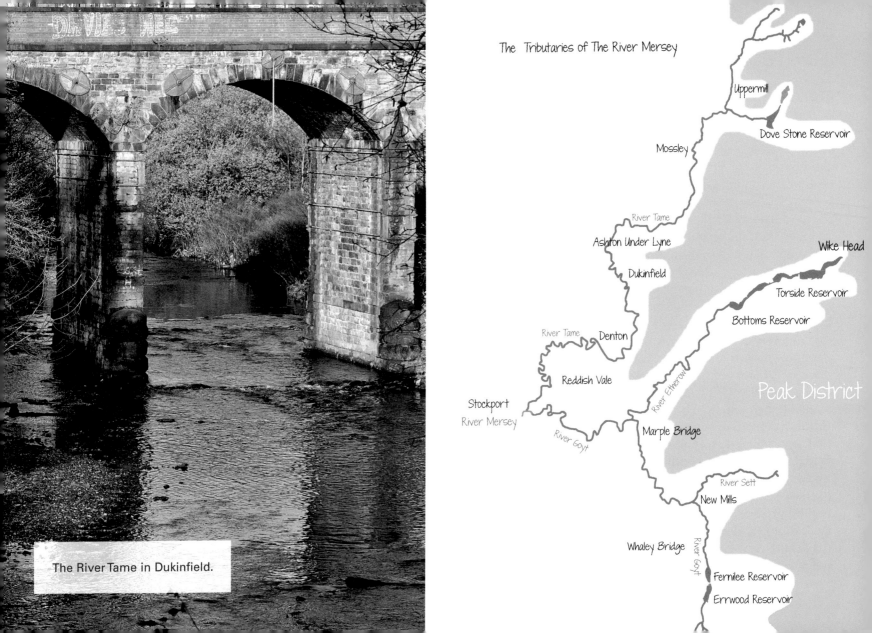

The River Tame in Dukinfield.

The Tributaries of The River Mersey

Uppermill

Dove Stone Reservoir

Mossley

River Tame

Ashton Under Lyne

Dukinfield

Wike Head

Torside Reservoir

Bottoms Reservoir

River Tame

Denton

Reddish Vale

River Etherow

Peak District

Stockport

River Mersey

Marple Bridge

River Goyt

River Sett

New Mills

Whaley Bridge

River Goyt

Fernilee Reservoir

Errwood Reservoir

THE RIVER GOYT AND THE GOYT VALLEY

There is something magical and appealing about the peaceful Goyt Valley, which lies in the heart of the Peak District in Derbyshire. This beautiful landscape is both rugged and remote, with the windswept moors surrounding much of the area, especially the reservoirs of Errwood and Fernilee. The reservoirs occupy part of the upper valley and provide water for the residents of Stockport. The river that flows through the valley is a classic Pennine spate river that rises on Axe Edge, near the famous Cat & Fiddle Inn, the second highest tavern in England at 1,690 feet. The river then passes through the villages of Whaley Bridge and New Mills, after forming the two reservoirs. The many walkers and people who visit leave with a genuine love of the valley and its history. There were once many thriving communities working in the many industries in this remote area of Derbyshire during the nineteenth and early twentieth centuries. However, the gunpowder works, the paint mill, the railway and the Victorian mansion are no longer standing.

The wealthy Grimshawe family, who built and owned the mansion, had a huge effect on the area, and their graveyard, the shrine to their Spanish governess, the thousands of rhododendrons that were planted and ruins of the house can still be seen. Whaley Bridge and New Mills both have an industrial history. In Whaley Bridge, the self-styled 'Gateway to the Goyt Valley', the Peak Forest Canal opened in 1800, and provided local industry with building materials and minerals. Then the Cromford and High Peak Railway opened for goods and passengers in 1831. It linked the Peak Forest Canal to the Cromford Canal approximately 32 miles away in a south-east direction. In New Mills, coal mining came before the cotton mills and printworks, which were built around 1788 in Torr Vale, just below the village. Iron and brass foundries moved into the gorge after a flood in 1872, and, unsurprisingly, the river was heavily polluted until the early years of the twenty-first century. However, since the 1970s there has been a programme to improve both the condition of the river and the surrounding area and there are now self-sustaining populations of trout and grayling in the river.

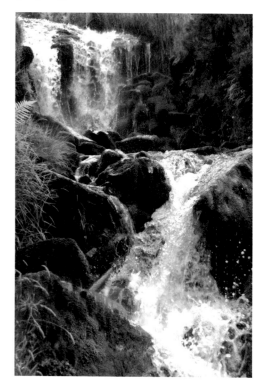

Right: The source elevation of the river is 520m, so there are a number of waterfalls on its way to joining the Mersey.

Opposite: The River Goyt flowing towards Errwood Reservoir, in the Upper Goyt Valley.

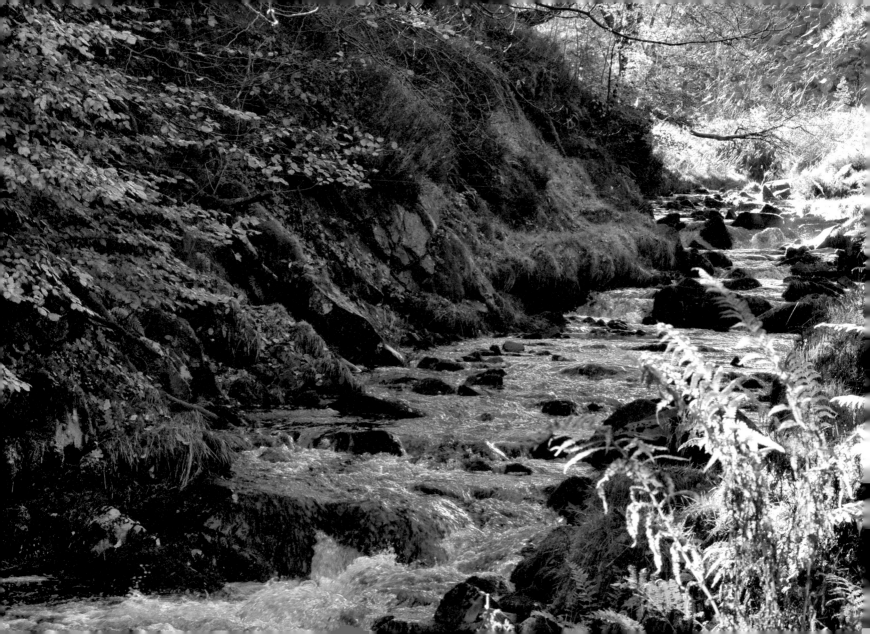

THE RIVER GOYT AND ITS TRIBUTARIES

The River Sett starts its journey near Edale Cross on Kinder Scout and flows through the villages of Hayfield and Birch Vale before joining the River Goyt at Torr Vale in New Mills. Hayfield is the traditional starting point for the ascent of Kinder Scout, a bleak and rugged moorland plateau rising to 636 metres, the highest point in the Peak District. The panoramic Kinder Reservoir, which lies to the north-east of the village, controls the flow of the River Sett, thereby avoiding the risk of flooding, which had previously been a serious problem in the village. At least two previous bridges on the river, occupying the site of the present bridge (which dates back to 1837), were swept away by the force of the river. The combined force of the Sett and Goyt has formed a gorge through the sandstone cliffs in Torr Vale, and together they feed a small hydropower system.

The source of the Etherow is Salter's Brook at Wike Head, to the east of Black Hill, and the stream initially flows south, forming the Derbyshire–Yorkshire border, before turning westwards into Longdendale. Once heavily wooded, even into the last century, Longdendale is now a fine, open valley with a series of reservoirs constructed by the Manchester & Salford Waterworks Company between 1848 and 1877. Relics of the oak woodland remain around some of the northern slopes of Bleaklow and at the eastern end of the valley. The Etherow and its tributaries are fast-flowing and constant, and therefore the river was an important source of power for industry along its route. It emerges again in Tintwistle, Derbyshire. The Etherow enters the borough of Tameside at Hollingworth in Greater Manchester, flowing into Stockport where it passes through Etherow Country Park. It flows into the River Goyt at Brabyns Park near Marple Bridge village.

Todd Brook is a small river that rises beneath Shining Tor on the border between Cheshire and Derbyshire. It passes by Kettleshulme before filling Toddbrook Reservoir in Derbyshire. The brook flows into the River Goyt at Whaley Bridge.

The river that flows towards Stockport, after these confluences, is still named the River Goyt.

Above: The River Etherow meets the River Goyt at Brabyns Park, Marple Bridge.

Opposite: The Rivers Sett and Goyt meet at Torr Vale in New Mills.

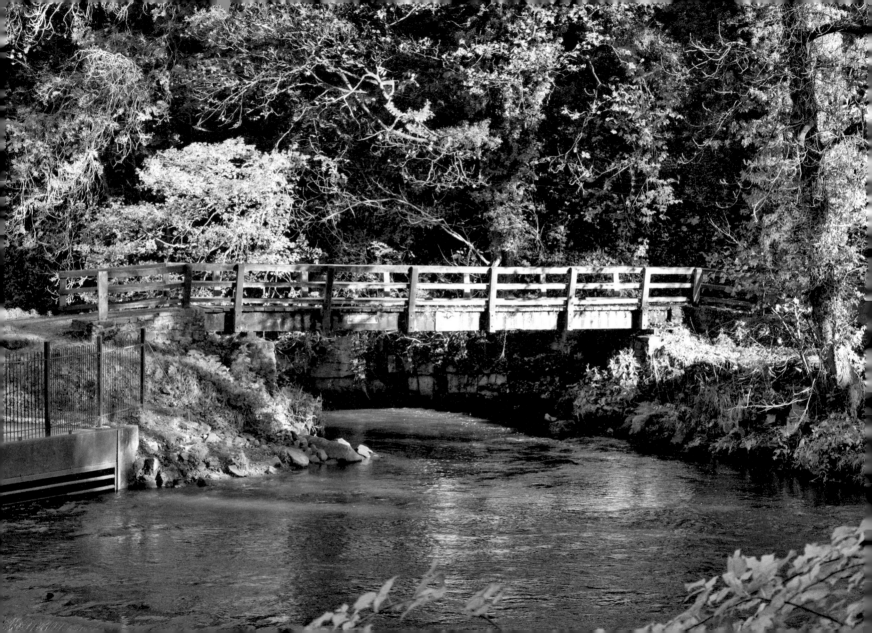

THE RIVER TAME

The source of the River Tame lies close to the Pennine Way in West Yorkshire. However, the 'named' river starts from Readycon Dean Reservoir on the moor above Denshaw, historically a part of the West Riding of Yorkshire but now a civil parish of the Metropolitan Borough of Oldham in Greater Manchester. The high moorland is sparsely inhabited, but there are fabulous views on a clear day. The upper Tame and its tributaries are comparatively shallow headwater streams, but water levels in the Saddleworth area rise very quickly after rain. Some of the headwaters are impounded for public water supply and some volumes of water are also taken from the river by the Huddersfield Narrow Canal. The river flows south through the historic, beautiful and photogenic Saddleworth villages of Delph, Dobcross, Diggle, Uppermill and Greenfield.

The industrial history of the area can be seen in the architecture of the buildings, which are constructed from locally quarried millstone grit. This material is difficult to carve, so many of the buildings are plain yet functional. The traditional small-scale home weavers' businesses became threatened during the late eighteenth century as the larger, purpose-built mills emerged, which were powered by the Tame and its tributaries. New village communities built up around these mills during the early nineteenth century. Diggle's New Mill had the biggest waterwheel in England at that time, and the large Alexandra Mill in Uppermill, which can still be seen, was steam-powered. There was also a paper mill at Greenfield and dye-works at Delph, so the river, much like the Goyt, was a polluted waterway during the nineteenth century, due to the dyes, bleaches and other effluents put into the river by the many mills. However, the anti-pollution efforts of the last thirty years of the twentieth century have resulted in many fauna distributions along the river being re-established. The Tame then flows through Reddish Vale Country Park, which lies in the Tame Valley, north of Stockport town centre. It is a place of recreation for the large populations of Brinnington and Reddish, offering a place of tranquillity and interest that is easily accessible.

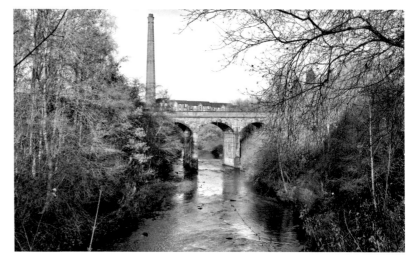

Above: The River Tame flowing out of the historical town of Dukinfield, Tameside, Greater Manchester.

Opposite: The River Tame passing alongside Alexandra Mill in Uppermill, Saddleworth, Greater Manchester.

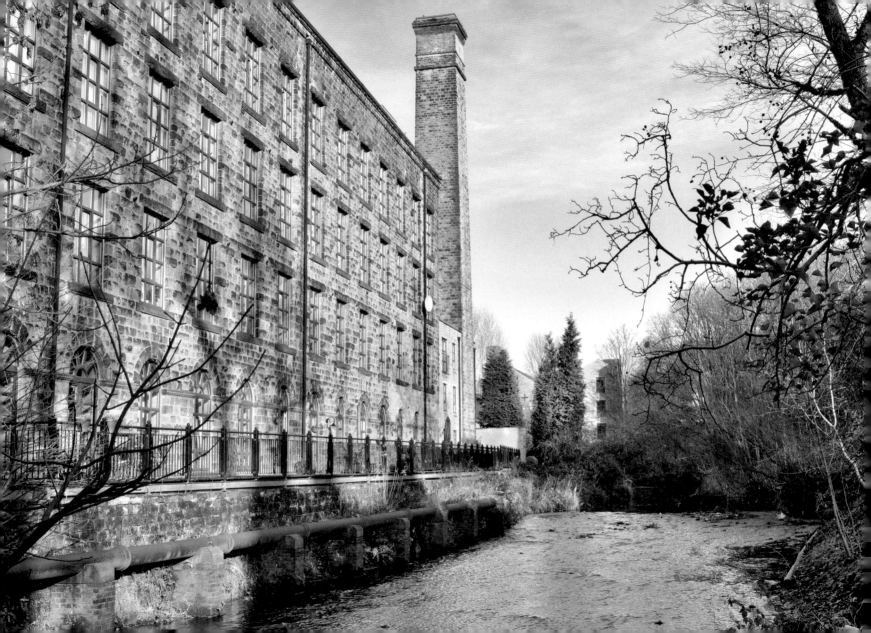

1
STOCKPORT TO IRLAM WEIR

The first part of the river's journey takes it away from the industrialisation of Stockport, through the leafy South Manchester suburbs of Heaton Mersey, Didsbury, Northenden, Chorlton and Sale. It then meanders through the old industrial heartland of Flixton and Cadishead, before eventually joining with the Manchester Ship Canal at Irlam Weir.

Almost hidden from view by Stockport's Merseyway Shopping Centre, the river starts its journey through the town's high crops of red sandstone and flows past the remnants of old Victorian mills, which litter the riverbed with fallen red bricks and other debris. After passing through new riverside commercial developments, it runs adjacent to the M60 for some distance, eventually losing the motorway as it heads east from Sale through Ashton-on-Mersey, Urmston and Flixton.

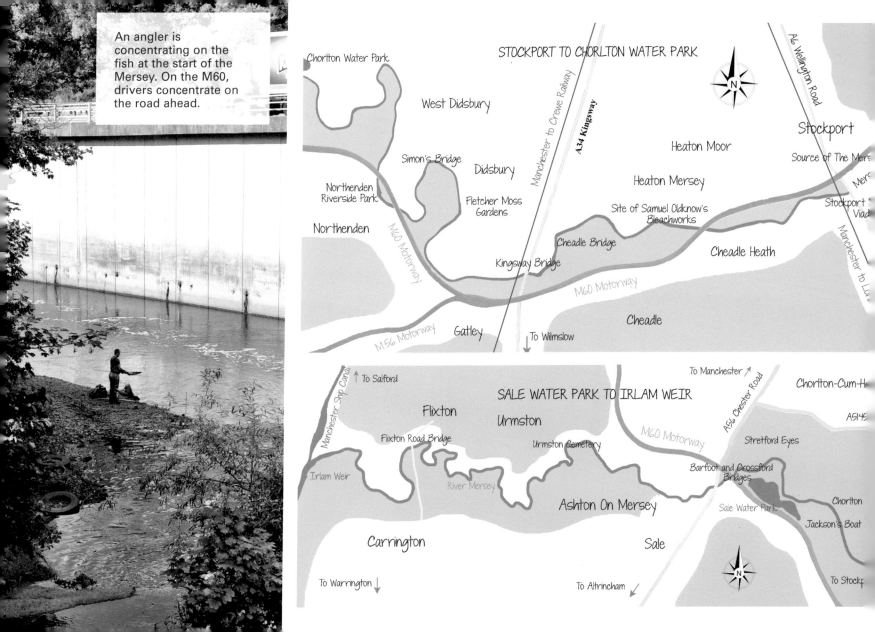

An angler is concentrating on the fish at the start of the Mersey. On the M60, drivers concentrate on the road ahead.

THE RIVER MERSEY STARTS

The River Mersey springs to life at the confluence of the rivers Goyt and Tame. Sandwiched between the concrete retaining walls of the M60, and the delivery entrance to a local supermarket, it is hidden away from the casual observer. However, it is marked by an impressive, wrought-iron sculpture, which lyrically claims 'Water is Life and Heaven's Gift. Here Rivers Goyt and Tame Become Mersey. Flowing Clear From Stockport to the Sea.'

The sculpture was placed here in 1994 as part of a project by Mind Stockport, in association with the residents of the local Lancashire Hill district; the piece incorporates artistic images that relate to Stockport's history and heritage. There are images of Victorian mills, local wildlife, a fisherman, a footballer and an aeroplane. Stockport has long stood on the incoming flight path for Manchester Airport, but it would be nice to think that, in part, the artwork remembers the seventy-two people killed in the Stockport air disaster of 1967.

The merging point of the two rivers has been practically inaccessible since the building of the M60 ring road and the associated alterations to the road structure around Stockport town centre. Prior to these modern developments, the two feeder rivers would have meandered through Stockport's mill land and celebrated their transformation into the Mersey at the open land surrounding the old cobbled bridge on Howard Street.

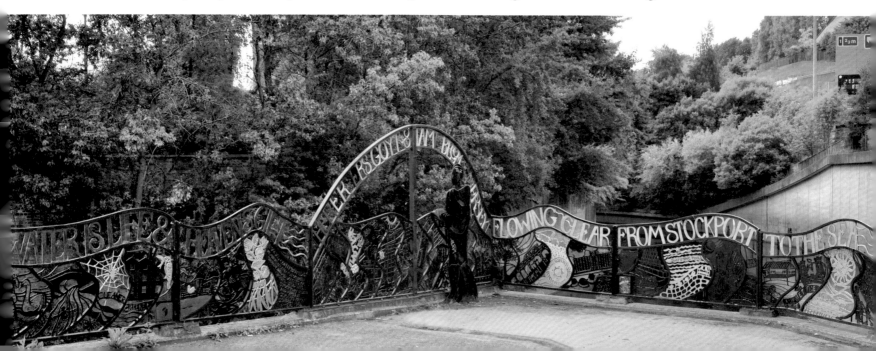

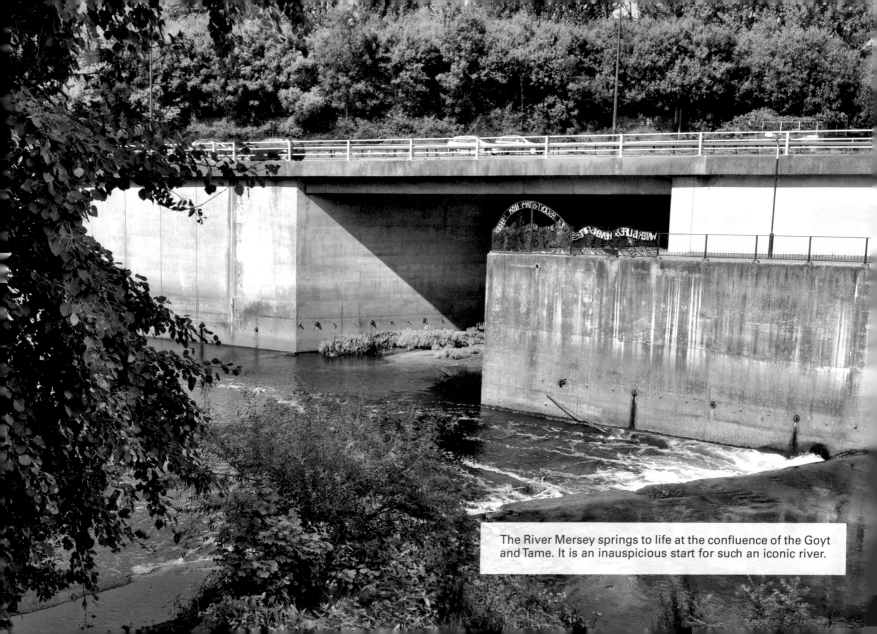

The River Mersey springs to life at the confluence of the Goyt and Tame. It is an inauspicious start for such an iconic river.

MERSEYWAY AND STOCKPORT

The rivers Goyt and Tame form the River Mersey just before entering Stockport but almost immediately the river disappears under the Merseyway shopping precinct, which has encased the waters and steep-sided banks since its completion in the mid-1960s. Here, the River Mersey then starts its 110km journey to the sea. The centre's name, Merseyway, comes from the fact that the centre is built on giant stilts above the River Mersey and the river runs under the entire length of the centre. It was one of the first shopping centres to open in 1965, and was refurbished in 1995. In 2001, there were plans to fit glass panels into the pavement within the centre to reveal the River Mersey underneath; this was to try to boost tourism in the town by providing spectacular views of the river swirling beneath the shoppers' feet. The centre and Stockport's shopping area attract about 14 million visitors per year, making it a popular shopping destination in the Greater Manchester Urban Area.

Right: The shoppers in Merseyway, Stockport, may not realise that the River Mersey is flowing beneath their feet.

Opposite: There is light at the end of the tunnel for the River Mersey as it emerges from underneath the Merseyway Shopping Centre.

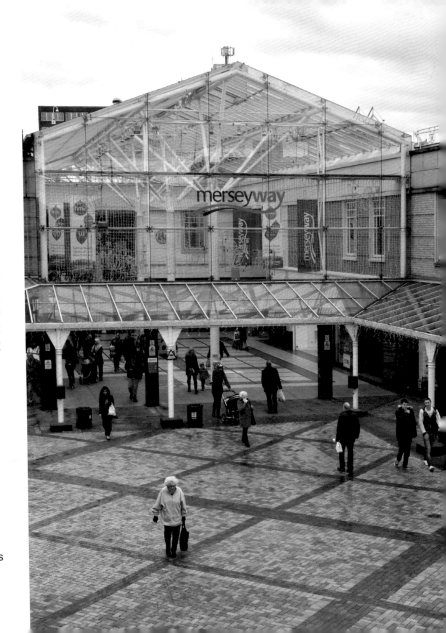

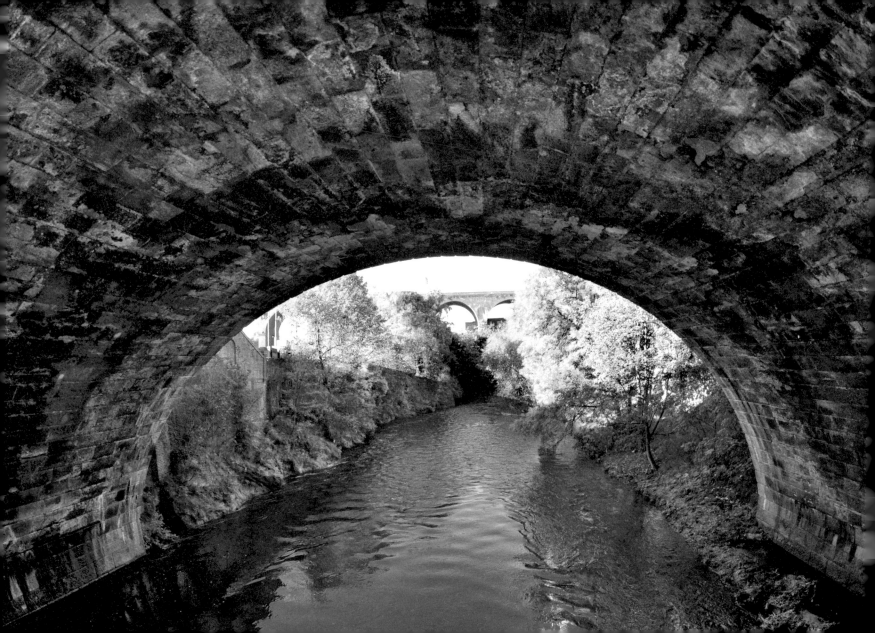

STOCKPORT VIADUCT

The river soon passes underneath Stockport's most distinctive landmark after leaving the Merseyway Shopping Centre. The Stockport Railway Viaduct is one of the largest brick structures in Britain and it features in the background of many L. S. Lowry paintings. It was built in 1840 to carry the tracks for the Manchester & Birmingham Railway over the River Mersey, and is still in use today. The level structure rises 33.8m above the riverbed, is 546.2m long and was originally 9.4m wide. It has 22 semicircular arches of 9.2m span.

The viaduct cost £72,000 to build and is reputed to contain 11 million bricks and 11,300 cubic metres of stone. The line from Manchester to Stockport opened on 4 June 1840, and the viaduct was completed on 21 December of that year. The first locomotive passed over it on 16 July 1841, followed by rail traffic from 10 August 1842. The viaduct gained Grade II* listing on 10 March 1975. Each of the three-lane carriageways of the M60 Stockport bypass (originally M63, constructed 1979–82) passes under a single arch of the viaduct. In 1989, the viaduct was cleaned and floodlighting installed during a £3 million restoration project.

Right: The caption written on this old photograph of Stockport Viaduct read: 'It is computed that the average number of trains passing over the viaduct in 24 hours is over 500.'

Opposite: The River Mersey leaves Stockport, flowing beneath the viaduct, on its long journey to the sea.

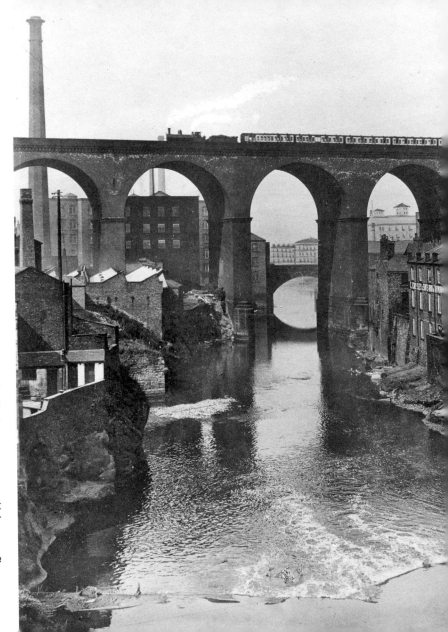

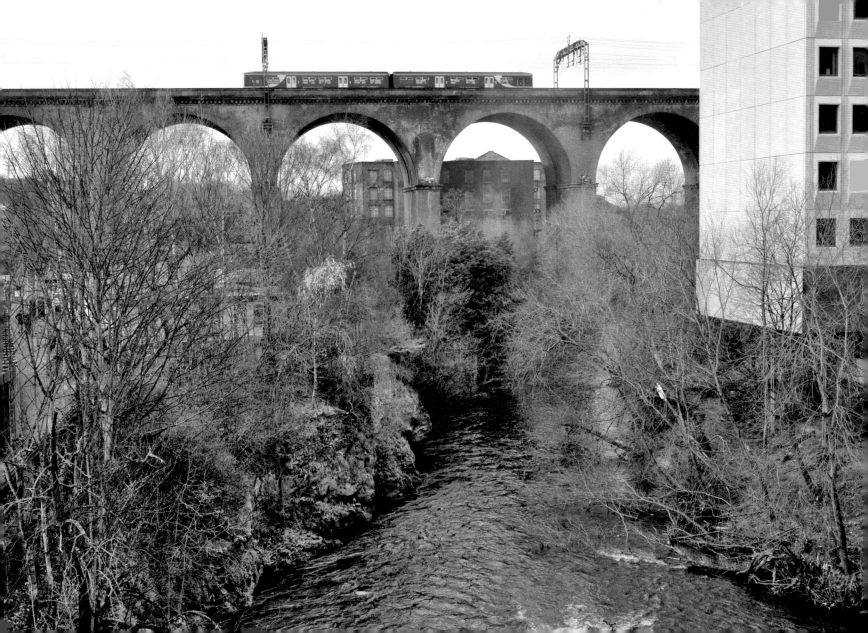

STOCKPORT BRINKSWAY TO VALE ROAD

The river leaves the viaduct passing by low-rise offices and the glass and concrete symmetry of the town's bus station, squeezing between modern retaining walls and the sides of derelict mill buildings. It passes remnants of Stockport's industrial past, glides under an old bridge by The Woolpack public house and past the Stockport Pyramid, a six-storey structure clad in blue glass. The Pyramid was completed in 1992 and was designed to be the first of five pyramids to be erected along this stretch of the river, which would be named the Kings Valley.

The Co-operative Bank took control of the building when the developer went bust before the valley could be completed and the single building now operates as their telephone banking centre. The sole legacy of the idea seems to be that Junction 1 of the M60 is now known to one and all as the 'Pyramid junction'. On the opposite bank to the Pyramid, there are steps down to the river. Through the foliage, on the Cheadle side of the river, can be seen the Brinksway caves set in the high crops of red sandstone, which are a feature of this area of Stockport. Heading west towards Heaton Mersey, the water runs clearly and long strands of riverweeds can be seen clinging to the red-brick debris of long-demolished structures and the shards of concrete that have fallen from the steep retaining walls. Finally escaping the town centre, the river flows under the M60 and follows the route of the old Cheshire Lines Railway towards the site of Heaton Mersey station.

Right: The many weirs across the Mersey are designed to alter its flow characteristics, helping to prevent flooding and allowing the river to flow steadily.

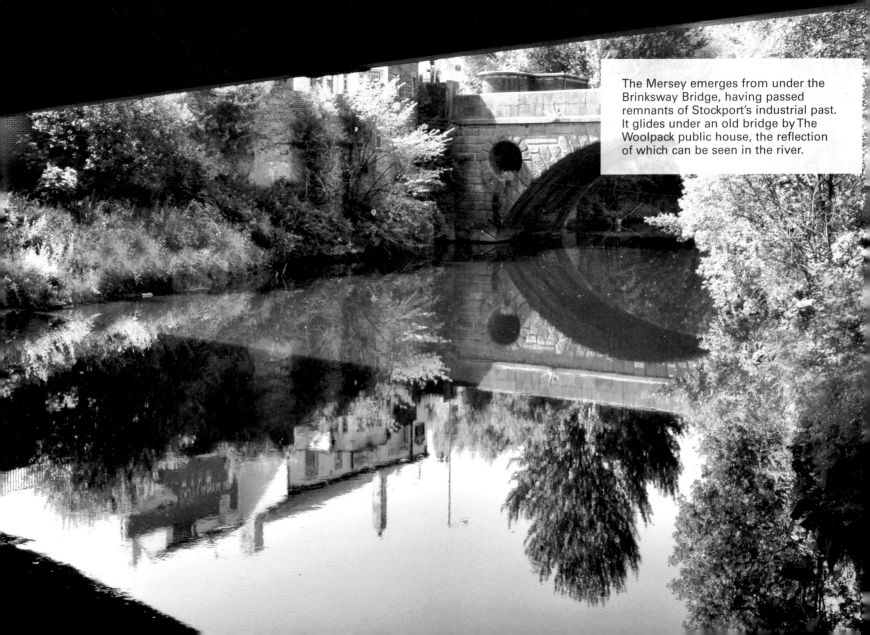

The Mersey emerges from under the Brinksway Bridge, having passed remnants of Stockport's industrial past. It glides under an old bridge by The Woolpack public house, the reflection of which can be seen in the river.

HEATON MERSEY AND SAMUEL OLDKNOW'S MILL

Heaton Mersey sits on a piece of elevated land looking down on the river, with views across the Cheshire Plain. The coming of the railway encouraged wealthy Victorian businessmen to build impressive villas here with money generated from commercial and industrial enterprises.

Samuel Oldknow, a cloth manufacturer, established a bleaching, printing and dyeing works on the banks of the river in 1785. It was instrumental in transforming Heaton Mersey from a rural, agricultural hamlet into a bustling Victorian village with a brickworks and bleach works, specialising in dyeing and printing. In little more than five years, between 1785 and 1790, the sounds of the village changed from the clop of horses' hooves and the burr of cartwheels on cobbles, to the hum of machinery and the clanking of railway wagons, set against a background of smoke and the smell of bleaching waste being pumped into a river already thick with pollutants.

As the population of the village increased, terraced houses were erected for the millworkers in Heaton Place, Park Row and Vale Close, all a stone's throw from the river. Many of the cottages are still there today, although their occupants are from different social strata to the poorly paid millworkers who resided there in the nineteenth century. Architecturally, the whole area around Vale Road has changed little since the nineteenth century, and a cobbled street still winds steeply past the cottages to The Crown Inn, a Grade II listed building, which offers food and fine ales, and is well worth the short climb from the river.

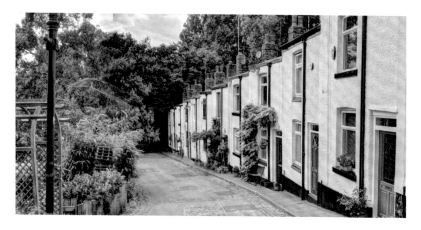

The millworkers' cottages on Park Row date from around 1830 and would have housed workers involved in the bleaching and dyeing industries.

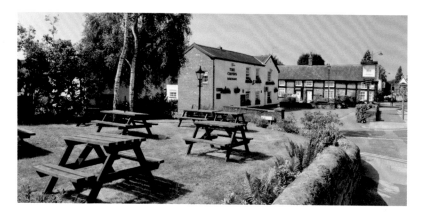

The Crown Inn, a short walk from the river, sits at the heart of Heaton Mersey village and maintains its village pub atmosphere. The timber-framed cottages to the right of the pub date from the sixteenth century.

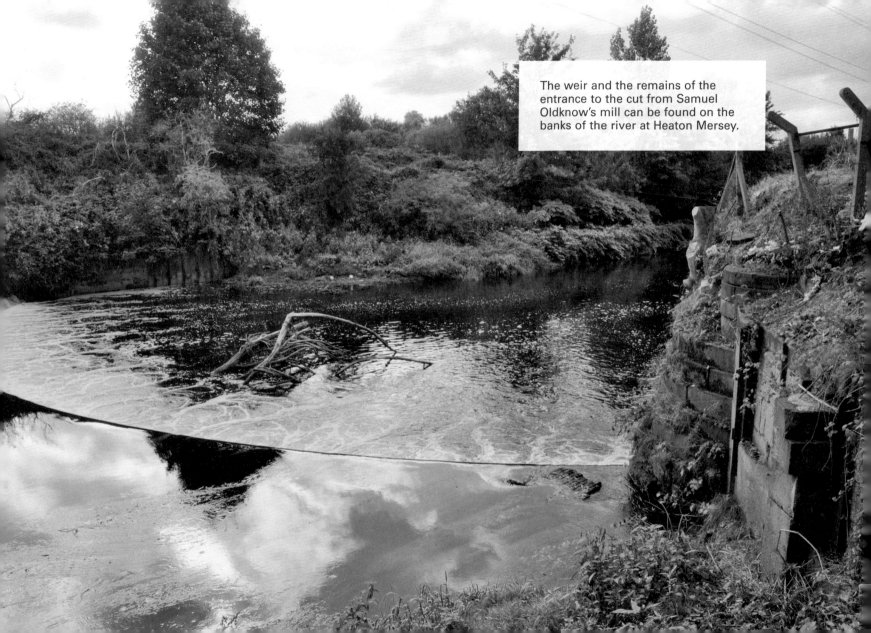

The weir and the remains of the entrance to the cut from Samuel Oldknow's mill can be found on the banks of the river at Heaton Mersey.

HEATON MERSEY TO DIDSBURY

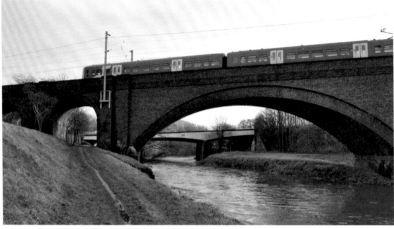

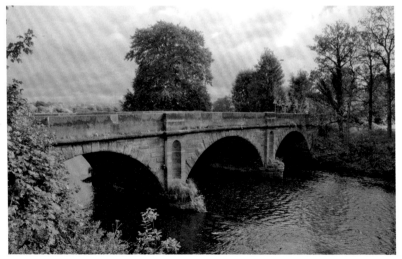

Above left: Remnants of Samuel Oldknow's mill can still be found on the stretch of the river between Heaton Mersey and Didsbury.

Above: Kingsway Bridge, seen here through the arches of the older bridge, which carries the main Crewe to Manchester railway line. Kingsway, the main road south out of Manchester, was extended across the river at Cheadle in 1959. Named after King George V, the dual carriageway originally opened in 1939, and was one of the earliest purpose-built roads, especially for motor vehicles and trams.

Left: A mile past the site of Samuel Oldknow's mill, the river passes the playing fields of Parrs Wood High School and flows under Cheadle Bridge on Manchester Road. This carved sandstone bridge, constructed in 1861, was once the sole crossing point of the Mersey, linking Didsbury to Cheadle Village.

Opposite: At the bottom of Stenner Lane in Didsbury is a large floodgate, which is closed in times of heavy rain to protect the quaint cottages that edge toward the bottom of the floodplain.

DIDSBURY AND FLETCHER MOSS

The village of Didsbury lies on the north bank of the Mersey, approximately 3 miles to the east of Stockport. It dates from Anglo-Saxon times and was of strategic importance as it was placed on a low cliff overlooking where the River Mersey could be forded.

On the edge of the floodplain, Fletcher Moss Park is well worth a visit. This 21-acre park is renowned for its botanical beauty and its gardens are home to many unusual plants and flowers. The park has retained many of its original features, such as the rock and heather gardens, and the orchid houses situated in the Parsonage Gardens. In the grounds can be found The Croft, an impressive detached building clad in ivy. It was sold by botanist Robert Williamson to alderman Fletcher Moss in 1912, and was the location of the first meeting of the organisation later to become known as the Royal Society for the Protection of Birds. A nature trail winds through woods and opens out onto the banks of the Mersey. There are tennis courts and the Alpine Tea Room, which serves tea, cakes and ice cream on most days of the year. The gardens are named after alderman Fletcher Moss, who donated the park to the city of Manchester in 1919. It is part botanical garden and part wildlife habitat. Fletcher Moss, born in July 1843, was a philanthropist who championed many public works in Manchester. His legacy remains today and the wildflower meadow, next to the riverbank, is a natural home to many species of plants and insects.

Right: An avenue of poplars rises out of the floodplain near Fletcher Moss Park.

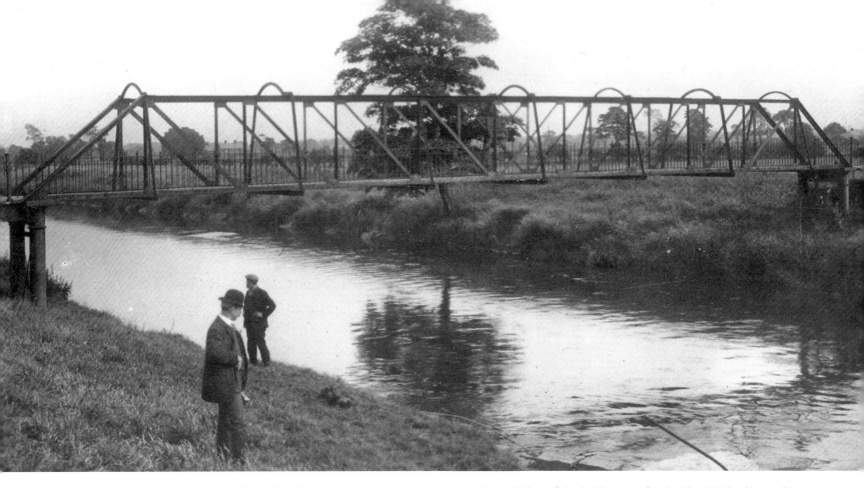

At the end of Ford Lane in Didsbury is Simon's Bridge. A completely iron structure, the building of the bridge was funded in 1901 by Henry Simon, a Prussian who was born in Silesia in 1835. He arrived penniless in Manchester in 1860, and within seven years had established himself as a consultant engineer with offices in the city centre. He designed a rolling flourmill plant for McDougall Brothers and revolutionised the development of coke through the use of 'beehive ovens'. Immersing himself in the life of the city, he was a co-founder of the Hallé Concerts Society and also Withington Girls' School. Eager to help the community, he provided the money for the bridge that enabled passage across the river from Didsbury to Poor's Field on the Northenden side. The field was owned by local churches and, with this easier access, they were able to acquire rent from local farmers, which paid for blankets and clothes for the needy.

NORTHENDEN AND CHORLTON WATER PARK

Just past Fletcher Moss, the river turns in an oxbow alongside the M60 and around Didsbury and Northenden golf clubs. In the past, this area has suffered badly from flooding. On 8 January 1932, the *Manchester Guardian* reported how eight people were marooned overnight in the clubhouse at Didsbury Golf Course when the river broke its banks after hours of heavy rain.

The Northenden Riverside Park is sited on the banks of the River Mersey between Palatine Road Bridge and the Tatton Arms Bridge. The Friends of the Northenden Riverside Park group organises events and walks along stretches of the river around the area. With support of the council, they have succeeded in regenerating this short stretch of riverbank, providing children's play facilities and benches for weary walkers to sit and enjoy the view.

Leaving Northenden, the river follows another oxbow curve and hugs the border with Northenden Golf Club before arriving at the edge of Chorlton Water Park. When the M60 was constructed in the 1970s, large amounts of gravel were excavated from the site and used in the construction of the motorway. On completion of the work, the gravel pit was subsequently flooded, creating the lake that is the main feature of the water park today. Over the last forty years, the site has developed into a green and inviting habitat for wildlife and the lake is a nationally important wintering site for water birds. Coots, moorhens, tufted ducks, geese, heron and even kingfishers are regular residents around the lake.

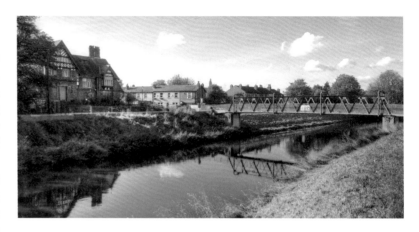

The Tatton Arms, which sits in a prominent position on the bank of the river within the Northenden Conservation Area, is now empty and waiting for new owners or a change of use. In its time it was a vibrant riverside pub where walkers could get much-needed refreshments and rowers and canoeists would moor up for a well-earned breather.

Chorlton Water Park has an abundance of wildlife along its banks.

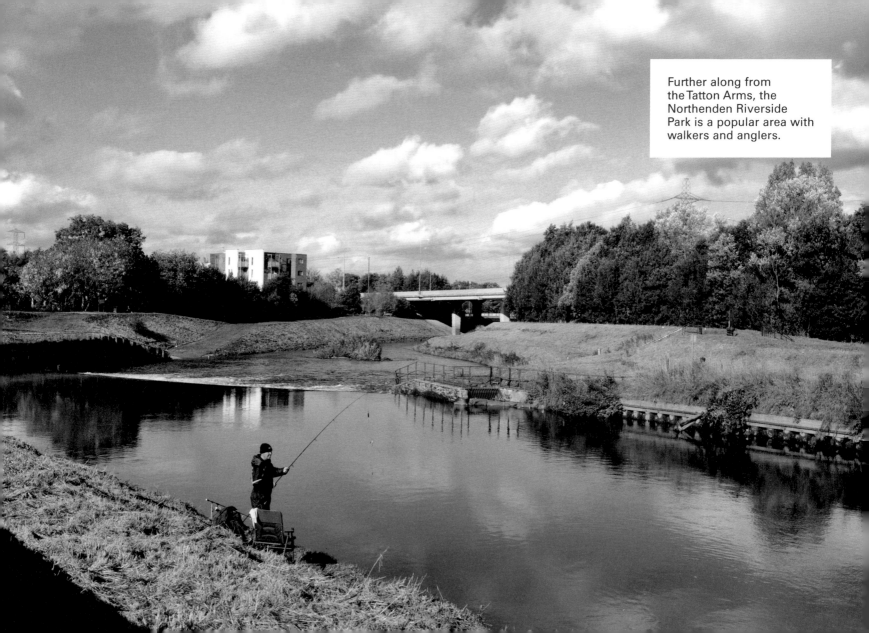

Further along from the Tatton Arms, the Northenden Riverside Park is a popular area with walkers and anglers.

JACKSON'S BOAT

The river flows for another half a mile before reaching a major east–west crossing point on the old Lancashire and Cheshire boundary, and a pub with history. Jackson's Boat has stood at this spot since 1663. It is the oldest pub in Sale and one of the oldest pubs in Manchester. Originally an old wooden building, it was a popular meeting place for Jacobites in the 1730s, who were attracted by the secrecy of its location, some distance from populated areas and surrounded by wooded fields where illegal cockfighting would take place. It is said that men like Colonel Towneley of the Manchester Regiment and the famous Dr John Byrom used to meet there regularly with other Royalists to drink the health of the King before joining the ill-fated 1745 rebellion.

The pub owes its name to Jackson, a local farmer, who ran a chain-operated ferry service to supplement his income. After the rebuilding of the pub in the early 1800s, a toll bridge was erected and the hostelry temporarily changed its name to The Bridge Inn. To cross the river pedestrians had to pay a fee of one halfpenny, but this was waived if the person concerned had business at the inn. The original wooden bridge was washed away in a storm and was rebuilt in 1881 as an iron girder bridge, which still charged a toll to cross the river.

The inn has had a long association with hauntings, most notably George the Jacobite who has been reported sitting quietly at the bar tasting the local ale, dressed in highland kilt. Strange shapes, noises and unexplained movements have been regularly reported around the bar area, and professional ghosthunters have visited the inn on at least one occasion.

Down the river from the iron bridge you can see two sluice gates, which form part of the Mersey's flood defences. There is one on each side of the river and they divert floodwater into the area surrounding Barlow Brook on the western bank and Chorlton Ees (pronounced 'eyes') on the east.

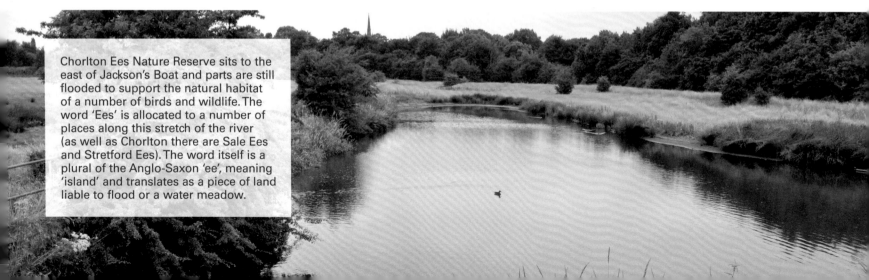

Chorlton Ees Nature Reserve sits to the east of Jackson's Boat and parts are still flooded to support the natural habitat of a number of birds and wildlife. The word 'Ees' is allocated to a number of places along this stretch of the river (as well as Chorlton there are Sale Ees and Stretford Ees). The word itself is a plural of the Anglo-Saxon 'ee', meaning 'island' and translates as a piece of land liable to flood or a water meadow.

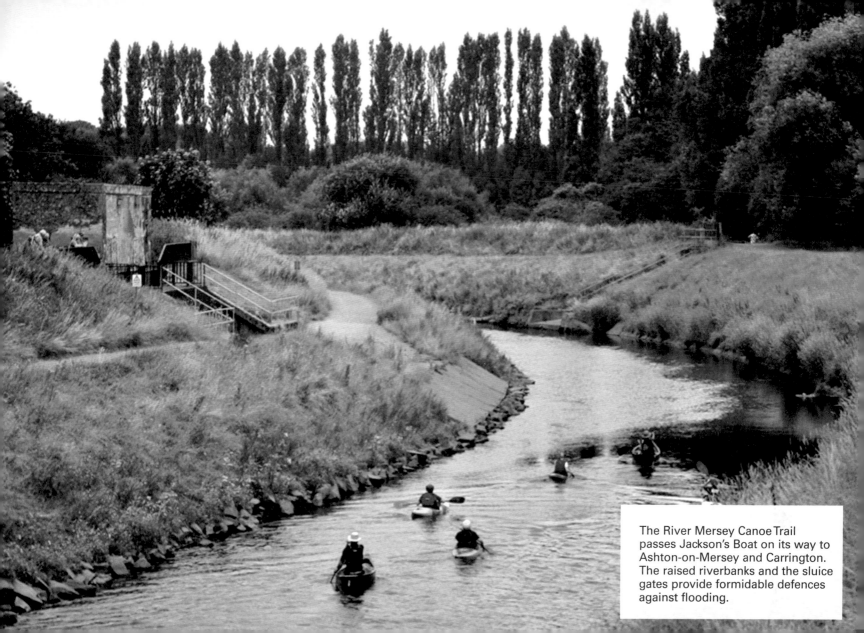

The River Mersey Canoe Trail passes Jackson's Boat on its way to Ashton-on-Mersey and Carrington. The raised riverbanks and the sluice gates provide formidable defences against flooding.

AROUND SALE WATER PARK

Sale Water Park is a 152-acre area of countryside and parkland that includes a 52-acre artificial lake. Like nearby Chorlton Water Park, it was formed in the 1970s by the flooding of a gravel pit. The pit had been excavated to provide material for the construction of an embankment to raise the M60 motorway 34 feet above the Mersey's floodplain. The park plays a significant part in local flood defences as a weir can be opened to allow water to flow from the river into the water park, where it can be stored until the floodwaters have passed.

There are paths on both sides of the river here, and a short distance after leaving the east bank of the water park the sound of the M60 disappears and the tranquil nature of the river walk is re-established. The banks along this stretch have been raised significantly and the elevated position affords a panoramic view of the network of trails that wind their way through meadows, woodland and rough grassland where there are many well-established ponds hidden among the trees.

Just past Chorlton Ees the river is crossed by the main railway line from Manchester to Altrincham. Barfoot Bridge, an old stone structure carrying the Bridgewater Canal, runs parallel to the railway and it is probably fair to say that it has seen better days – the significant cracks crisscrossing the main pressure points look in urgent need of attention.

As the river moves east it reunites with the M60 motorway for the last time, passing under the slip roads for Junction 7 and the main A56, which crosses the Mersey at Crossford Bridge. In 1745, Crossford Bridge, which dated back to around 1367, was torn down. It was one of a series of bridges crossing the Mersey deliberately destroyed by order of the government to slow the Jacobite forces during the uprising. Upon reaching Manchester, the Jacobites rebuilt the bridge and used it to send small forces into Sale and Altrincham with the intention of deceiving the authorities that the Jacobites were heading for Chester. The tactic was successful and the main Jacobite army had an untroubled route south back along the line of the Mersey through Cheadle and Stockport.

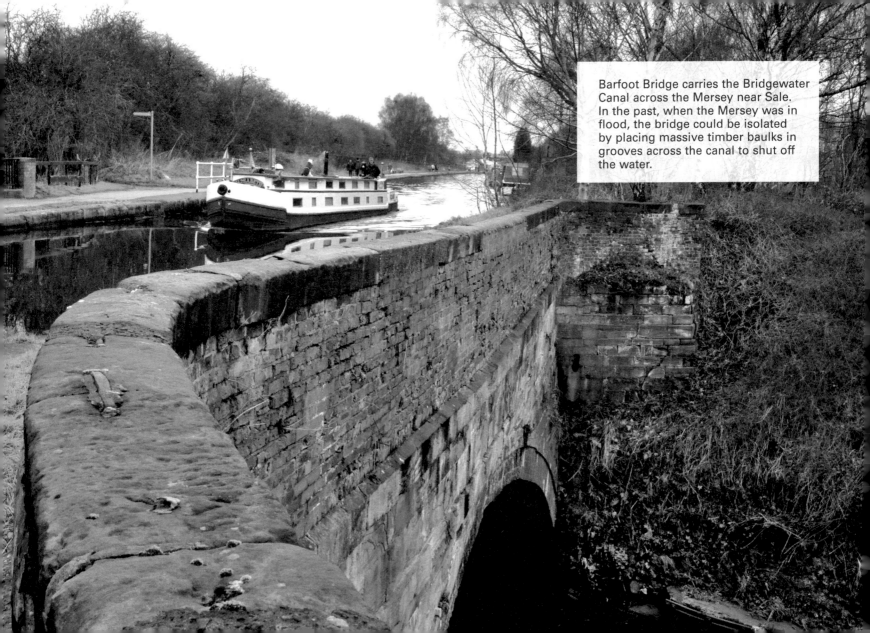

Barfoot Bridge carries the Bridgewater Canal across the Mersey near Sale. In the past, when the Mersey was in flood, the bridge could be isolated by placing massive timber baulks in grooves across the canal to shut off the water.

ASHTON-ON-MERSEY TO IRLAM WEIR

Ashton-on-Mersey sits north of Sale, on the southern bank of the river, but its actual boundaries are quite obscure and it is now part of the urban district of Sale. Its main claim to fame stems from the discovery of a fourth-century hoard of forty-six Roman coins. It is one of four known hoards dating from that period discovered within the Mersey basin, the most famous being the 2,459 Roman coins found in 1957 at Wolstencroft Farm, in nearby Dunham.

As the river leaves Ashton it turns sharply east, leaving its proximity to the M60 and its northern bank touches on the southern areas of Flixton and Urmston. Urmston too has a Roman connection. Urmston Cemetery, which borders the river, was once the site of Urmston Old Hall, and during an excavation in 1983, fragments of Roman pottery were uncovered, giving rise to the theory that there could have been a Roman settlement on the banks of the river.

Meandering east from Urmston, the river enters the boundaries of Flixton. There is some evidence that the area was the location of Neolithic and Bronze Age settlements, and stone axes have been found on the banks of the Mersey. The road bridge to the south of the town dates from 1907, and replaced a wooden structure that was too narrow for carts to negotiate. There is evidence that river fords existed nearby at Flixton church and Shaw Hall.

The junction of the Mersey and the Ship Canal marks the site of the old Irlam Steelworks. Steel manufacture was a major source of employment in Irlam for a much of the twentieth century. The Partington Steel & Iron Company opened the first steelworks in Irlam in 1910, but by 1979, all steel production in Irlam had ceased. The works was a major pollutant of the river, and the weir was often clogged with chemical foam and other clumps of assorted industrial debris. The steelworks was a huge landmark in the area and anyone who travelled the Manchester–Liverpool Railway line after nightfall will remember lights of cityscape proportions illuminating the surrounding area.

Urmston Cemetery sits close to the river on land once occupied by the Romans.

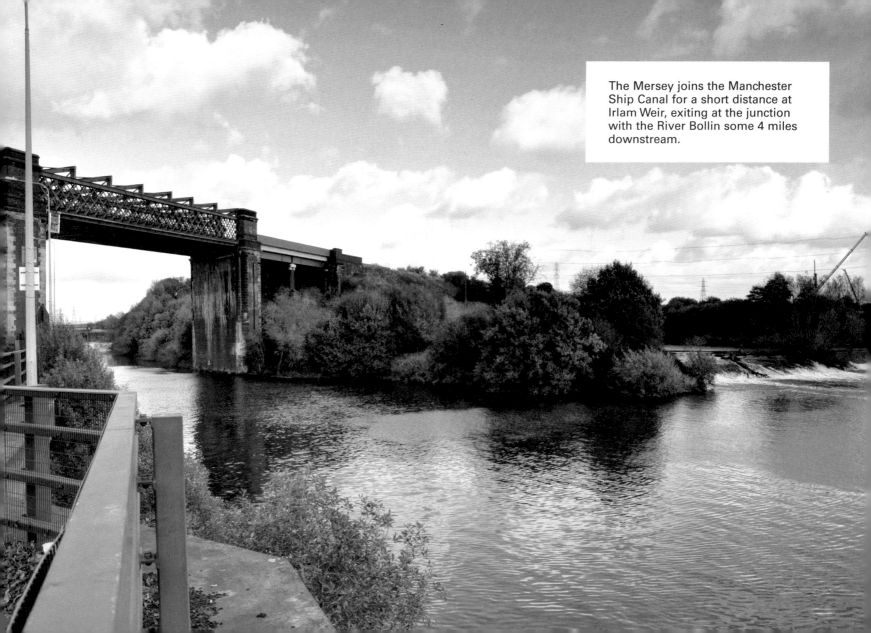

The Mersey joins the Manchester Ship Canal for a short distance at Irlam Weir, exiting at the junction with the River Bollin some 4 miles downstream.

IRLAM WEIR TO HALTON CASTLE

The Mersey marries with the Manchester Ship Canal after flowing over Irlam Weir. On its way to its tidal estuaries, it is touched by sections of locks and cuts built in an effort to make the river more navigable for the sailing vessels that strove to ply their trade up to and beyond its tidal reaches.

The line of the old Black Bear Canal near Victoria Park marks one of the more ambitious projects to address the river's navigational limitations. It was once part of an 8-mile canal between Latchford and Runcorn, specifically built to avoid the awkward tidal stretch between Runcorn and Warrington, including the 'Hell Hole' – a sharp loop in the Mersey where boats regularly ran aground in the silt and sandbanks.

The idea that the River Mersey and River Irwell could be made navigable between the Mersey Estuary and Manchester was proposed in 1712 by Thomas Steers, a civil engineer, who had studied earlier plans first produced in 1660. Prior to this, goods between Manchester and Liverpool were either transported by railway or along an extension of the Bridgewater Canal from Runcorn.

However, the route along the two rivers was fraught with navigational problems. Only smaller ships were able to make the journey successfully, and during times of low rainfall or strong easterly winds that held back the tide, there was not always the depth of water to allow safe passage for boats carrying a full cargo. By the late nineteenth century, long stretches of the Mersey and Irwell routes had fallen into disrepair and were often unnavigable.

At the behest of local businessman Thomas Walker, one of the most skilful civil engineers of his day, was appointed as project co-ordinator to build the Manchester Ship Canal. He estimated it would take 4½ years to complete, at a cost of £5.25 million.

However, Walker underestimated the scale of the operation, and the canal eventually cost over £15 million by the time of its opening in 1894 (around £2 billion in today's money). One million pounds alone accounted for the wages of the navvies.

It is to the east of Warrington that we start to get a real flavour of the river's regeneration, leaving behind its grim, polluted past and shedding the industrial dark clouds that shrouded it for nearly two centuries. Although there are still pockets of industrial development, the Trans Pennine Trail opens up the route to walkers and cyclists looking for fresh air, and the abundance of wildlife now flocking back to its banks.

Opposite: This section of the journey marks the Mersey's change from a slow-moving, narrow river to a wild, spacious, tidal estuary.

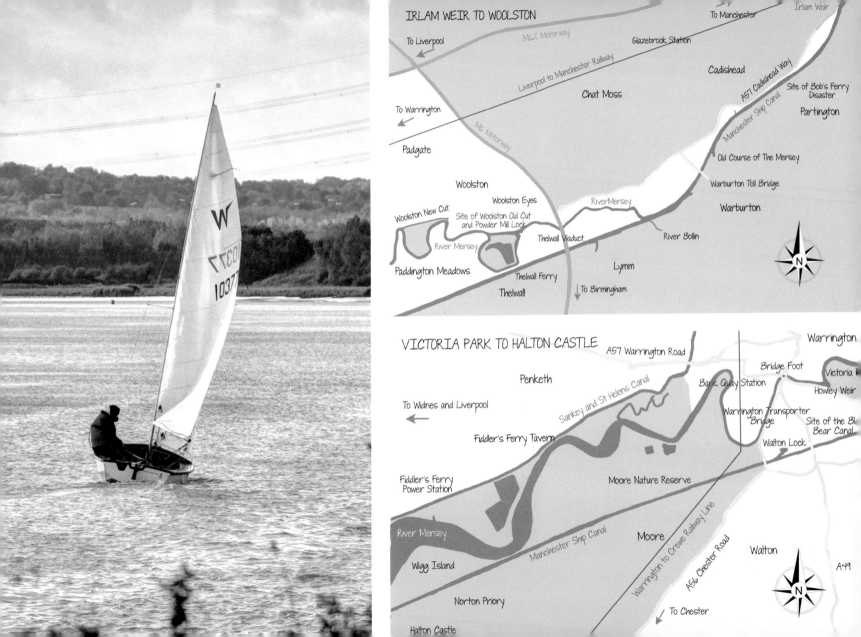

IRLAM WEIR TO WOOLSTON

To Manchester
Irlam Weir
To Liverpool
M62 Motorway
Glazebrook Station
Cadishead
A57 Cadishead Way
Site of Bob's Ferry Disaster
Liverpool to Manchester Railway
Chat Moss
Manchester Ship Canal
Partington
To Warrington
M6 Motorway
Old Course of The Mersey
Padgate
Warburton Toll Bridge
Woolston
Woolston Eyes
River Mersey
Warburton
Woolston New Cut
Site of Woolston Old Cut and Powder Mill Lock
River Bollin
River Mersey
Thelwall Viaduct
Lymm
Paddington Meadows
Thelwall Ferry
To Birmingham
Thelwall
N

VICTORIA PARK TO HALTON CASTLE

Warrington
A57 Warrington Road
Penketh
Bridge Foot
Bank Quay Station
Victoria
Sankey and St Helens Canal
Howley Weir
To Widnes and Liverpool
Warrington Transporter Bridge
Site of the Black Bear Canal
Fiddler's Ferry Tavern
Walton Lock
Fiddler's Ferry Power Station
Moore Nature Reserve
River Mersey
Warrington to Crewe Railway Line
Manchester Ship Canal
Moore
Walton
A49
Wigg Island
A56 Chester Road
Norton Priory
To Chester
N
Halton Castle

CHAT MOSS, CADISHEAD AND PARTINGTON

Chat Moss is a large area of peat bog that covers an area of 10 square miles just to the north of where the Manchester Ship Canal plays temporary host to the river.

Until the early nineteenth century, Cadishead was part of Chat Moss but with the draining of the land and the construction of the Manchester Ship Canal, Cadishead developed into a substantial town, supplying labour for the many industries that had sprung up along the canal's banks.

Chat Moss was drained successfully in the nineteenth century and George Stephenson succeeded in constructing a railway line through it in 1829. His method involved the construction of facines, which were rough bundles of brushwood or other material used for strengthening the earthen structure, on which to 'float' the line.

The peat has major preservative properties, and in the late nineteenth century a Bronze Age canoe, now in Salford Museum, was unearthed. In 1958, another significant archaeological discovery was made when workmen digging peat in an area of Chat Moss near Worsley discovered a severed head, which radiocarbon dating placed around the late Iron Age. The head was identified as a Romano-British Celt, named Worsley Man, and is now in the care of the Manchester Museum.

Leaving Chat Moss, the Mersey flows with the canal and passes between the suburbs of Partington and Cadishead. The Cadishead Railway Viaduct still spans the canal, but passenger services on this line ceased completely in 1964 and major corrosion has now set in on the structure. It is blocked at both ends by cargo containers to prevent public access.

Partington is situated on the western side of the Cadishead Bridge. Until the 1960s, it had a relatively small population of around 700 people. But when Manchester City Council decided to pull down the dilapidated Victorian terraced housing in the city centre, Partington became the location for an 'overspill' estate. Acres of housing developments were built and the people of Manchester moved out to develop new lives. The new residents of Partington often struggled to find work and it became one of the most deprived areas in the Greater Manchester. Today, community groups are active in supporting the social and commercial regeneration of the town.

Cadishead Railway Viaduct once supported a spur from the Manchester to Liverpool line, which headed south to Stockport Tiviot Dale.

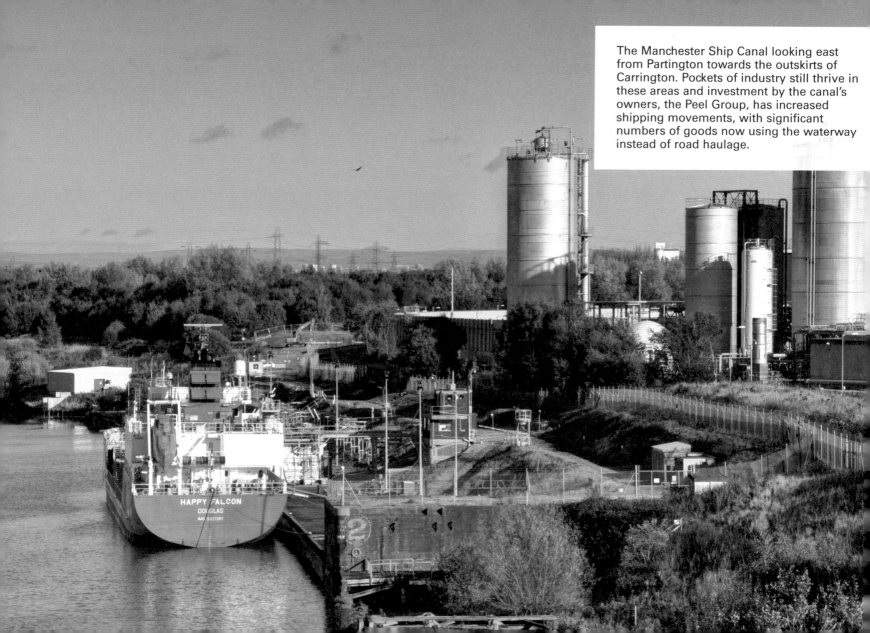

The Manchester Ship Canal looking east from Partington towards the outskirts of Carrington. Pockets of industry still thrive in these areas and investment by the canal's owners, the Peel Group, has increased shipping movements, with significant numbers of goods now using the waterway instead of road haulage.

THE BOB'S LANE FERRY DISASTER, 1970

Just as the canal leaves the southern edges of Cadishead and Partington, a small inset of land on the Partington bank marks the former site of the landing stage for Bob's Lane Ferry. Before the building of the Manchester Ship Canal, the ferry operated across the Mersey. The crossing, which took only a few minutes, started at 5.30 a.m., in order to get the early shift workers over the water to Carrington, and continued until 11.00 p.m., with trips every 15 minutes.

However, on Tuesday 14 April 1970, disaster struck and the lives of five local men were lost. The ferryman on the day was a local man called Bernard Carroll. After the first couple of crossings, he had decided to suspend the service because of an unpleasant smell coming from the river and phoned the police for advice.

As he was making the call, several workers, worried that they would be late for their shifts, decided to row themselves over the canal. When Bernard returned from the phone there was a heavy mist on the canal and the occupants in the boat were having some difficulty navigating. In order to help, Bernard jumped into another boat and started towards them.

A number of people waiting on the bank then witnessed a terrible event. When Bernard was approximately 20 yards from the boat, the canal burst into flame, engulfing both craft. This was followed by a further series of explosions and a conflagration 60 foot high that stretched over a mile along the canal. Nearby houses were rocked by the explosion and all the dwellings in Lock Lane had to be evacuated. The boats could not be reached by rescue craft until the flames had subsided, by which time Bernard had died and five men in the other boat had been badly burnt. Three other passengers from the boat had disappeared and it was over two weeks before their bodies were recovered from the canal. One of the surviving passengers died some days later from the terrible burns he had received.

Following an investigation, Shell Chemicals announced they had suspended two of their workers and the cause behind the disaster was revealed. A few hours before the explosion, the Dutch vessel *Tacoma* was being loaded with nearly 400,000 gallons of petrol at the Partington Coal Basin. The two Shell employees admitted that instead of being on the quayside monitoring petrol flow into the ship, they had gone to the canteen and remained there for around four hours. During this period it was estimated that 14,000 gallons of pyrolosis gasoline, which has a low flash point, overflowed into the canal. There was a suggestion that the fire started when one of the ferry passengers lit a cigarette, but this was never formally proven.

A verdict of death by misadventure was recorded on the five men who died. At the time of writing, the erection of memorials is planned for both sides of the river on the 44th anniversary of the disaster.

Opposite: The Manchester Ship Canal looking west from the top of the disused Cadishead Railway Viaduct. The tall chimney marks the point of the Bob's Lane Ferry disaster.

Inset: The Bob's Lane Ferry in the late 1960s. At the time of the disaster, a diesel engine craft operated by a ferryman carried passengers across the river throughout the day. A rowing boat was held in reserve in case the newer boat developed mechanical problems.

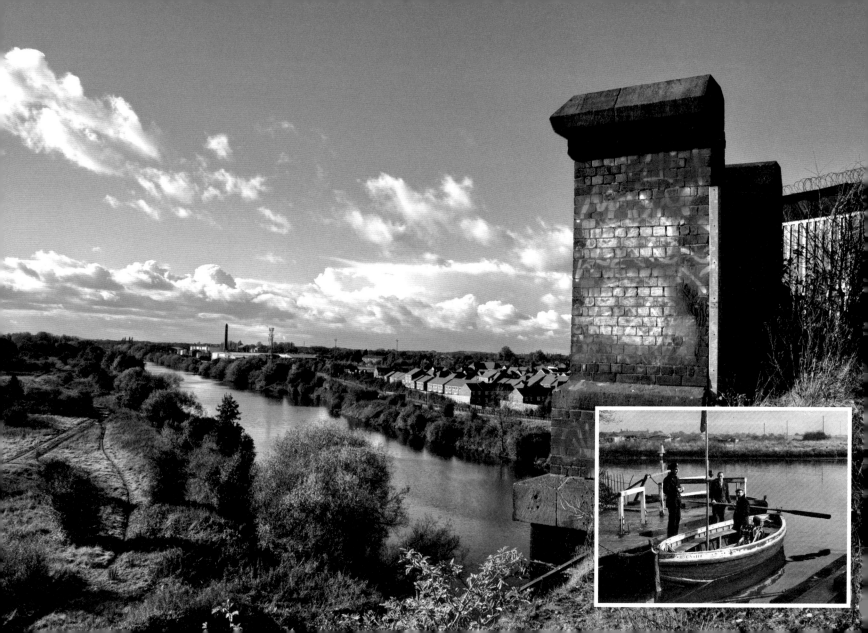

WARBURTON VILLAGE

As the river turns south, leaving Partington and Cadishead behind, it enters the rural farming area of Warburton. Just before Warburton Bridge, there is an inlet in the canal bank that indicates the actual route of the Mersey before the short meander of around half a mile was replaced by the more direct route of the canal. A third of a mile south, down Warburton Bridge Road, lies Warburton Bridge, a privately owned toll point that was the original crossing point of the river. It is one of the few remaining pre-motorway toll bridges in the United Kingdom, and the only one that exists in Greater Manchester. Motorists are charged 12p for a single crossing or 25p for a day ticket.

From the bridge, the dried up stretches of the Mersey can be seen on both sides. Just to the south of the original route of the Mersey lies the village of Warburton, now a riverside village without a river. Unlike its near neighbours, Warburton was practically untouched by the Industrial Revolution and maintained its status as a farming village, which dated back to the medieval period. Today it is a small leafy village in the Borough of Trafford, with a population of less than 300.

Despite its size, there are seventeen listed buildings in the village, including the timber-framed church of St Werburgh, which has Grade I listed status. It has a quaint brick tower at its eastern end, and inside its oak beams and rafters are said to be secured with the antlers of deer. Some of the gravestones in the churchyard are said to be nearly 800 years old.

Warburton is also a place of legends. It is said that wives were bought and sold under the old market cross on Townfield Lane and that Dick Turpin hid in the village during one of his escapades, possibly escaping from a robbery he had committed at new Bridge Hollow in Bowden, a short distance away. There is legend also that the church of St Werburgh stands on the site of an old Saxon church founded by the daughter of Alfred the Great, although this has never been established by any archaeological investigation.

Above: Named after a Saxon abbess, St Werburgh's old church is one of only twenty-seven timber-framed churches in England.

Opposite: The old toll crossing over the Mersey is still in use just outside Warburton village. However, the river is no longer there and the bridge straddles a dried-up riverbed.

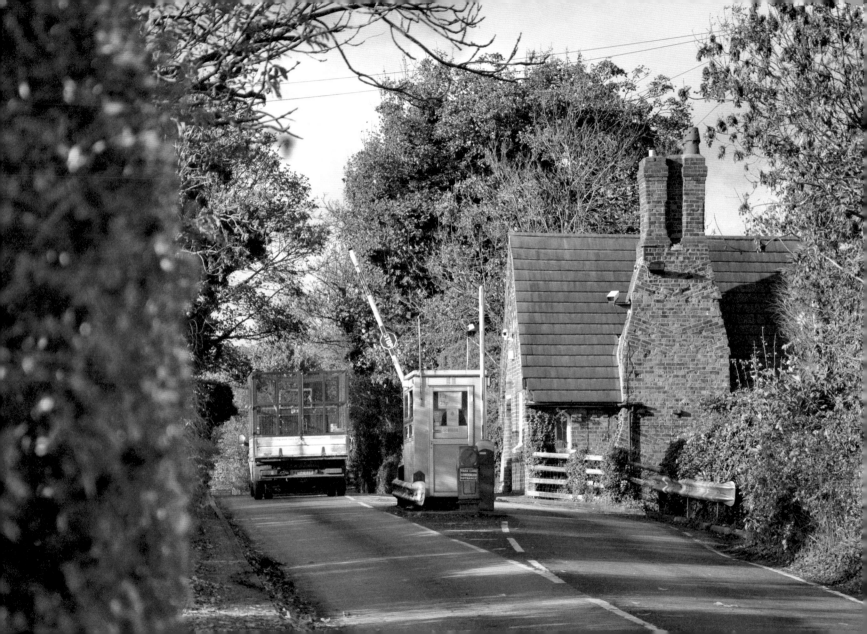

THELWALL VIADUCT

A few hundred yards past the outskirts of the village of Warburton, the Mersey escapes the confines of the Ship Canal, meeting with the River Bollin and flowing east to meet one of its major arterial crossing points: the Thelwall Viaduct on the outskirts of Warrington. The viaduct, carrying eight lanes of the M6, carves its way through the flat countryside of Lymm and Thelwall, and is one of the busiest motorway routes in the country.

Thelwall Viaduct is 4,414 feet long and rises to a height of 93 feet above the Manchester Ship Canal, which runs parallel with the Mersey. Work on the viaduct commenced in 1961, but early construction was difficult due to soft alluvial deposits over the whole of the site. The land between the canal and the Mersey had been used for the disposal of waste from canal dredging and had layers of silt up to 45 feet deep in places.

Reinforced concrete piers, between 30 and 80 feet in height, had to be pile driven into the earth in order to provide stable foundations. At the time of its opening in July 1963, it was the longest motorway bridge in England, with a single span of 336 feet crossing the Ship Canal. The bridge suffers from its isolated location high above the flat expanse of fields surrounding the canal and the river. Its openness to the elements regularly requires speed restrictions and often closure to high-sided vehicles when wind speeds reach their peak. One of the problems with its design was that the sides of the bridge were deliberately left open to reduce the risk of snowdrifts developing on the carriageways.

The Manchester Ship Canal Company allow Woolston Eyes Conservation Group to manage the area that flanks the meandering course of the Mersey beneath the bridge, which is home to many species of wildfowl. In all, 232 species have been recorded on the reserve, including 13 species of raptor, more than 30 species of wader, all 5 grebes, the 3 woodpeckers, and 5 species of owl. Over 110,000 birds have been ringed at Woolston since 1980. During more recent years, Woolston has taken part in an international ringing programme, aimed at studying those migratory species that winter in Africa.

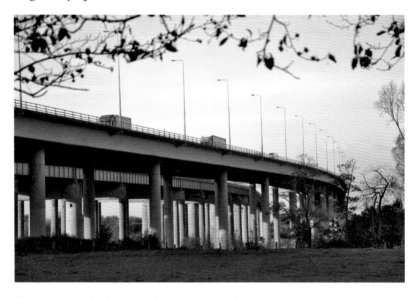

The Thelwall Viaduct consists of two entirely separate bridges. At 4,414 feet long, the northbound carriageway was the longest motorway bridge in England when it opened in July 1963.

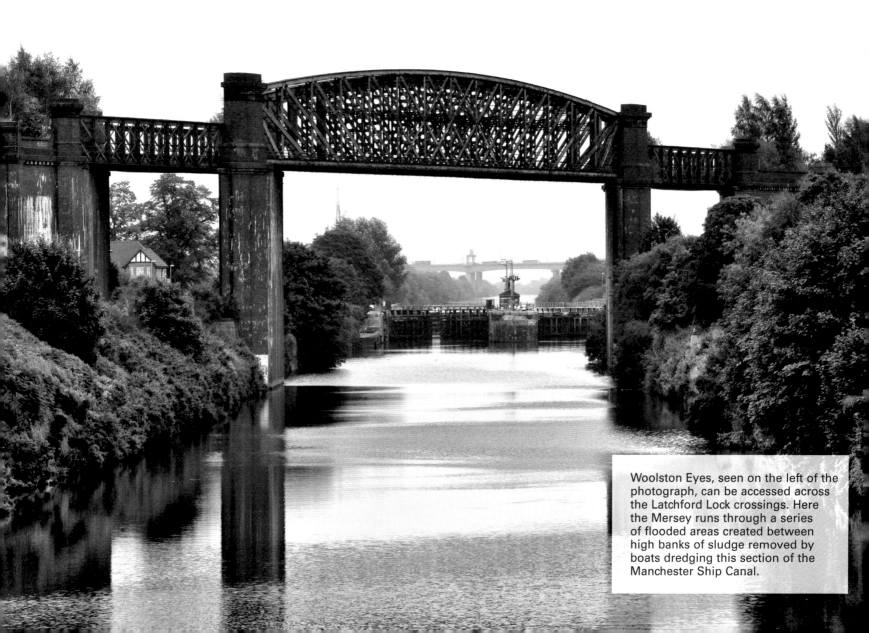

Woolston Eyes, seen on the left of the photograph, can be accessed across the Latchford Lock crossings. Here the Mersey runs through a series of flooded areas created between high banks of sludge removed by boats dredging this section of the Manchester Ship Canal.

THELWALL VILLAGE AND FERRY

The village of Thelwall does not yield itself up to the casual traveller, tucked away as it is from the main 'A' roads and cut off from the Mersey by the Ship Canal. Before the construction of the canal, Thelwall was connected to Woolston on the outskirts of Warrington by a ferry across the Mersey. This fell into disuse in the eighteenth century when a short stretch of canal, Woolston Cut, was constructed to save vessels the detour around one of the Mersey's larger oxbow twists, which had its southerly point just north of the village. However, travel to the end of Ferry Lane, which was once the route to the old ferry, and you will find a daily service in operation, which transports passengers across the Ship Canal at a charge of 11p per trip.

Thelwall is a pleasant village and has a number of interesting buildings to complement some picturesque, half-timbered cottages. The stained-glass window in the church celebrates the life of Sir Peter Rylands, who was involved in the manufacture of wire at nearby Warrington, giving the local rugby league team its traditional nickname of 'The Wires'. At the centre of the old village is an attractive row of nineteenth-century cottages containing the post office, and the seventeenth-century old hall can be found in Ferry Lane.

Right: The Pickering Arms is situated in the middle of the village opposite Ferry Lane. On its wall can be found the inscription, 'IN THE YEAR 923, KING EDWARD THE ELDER FOUNDED A CYTY HERE AND CALLED IT THELWALL.'

Opposite: The Thelwall Ferry across the Manchester Ship Canal runs every day (except Sunday morning), carrying passengers from Thelwall village to the nature reserves around Woolston Eyes and the Mersey.

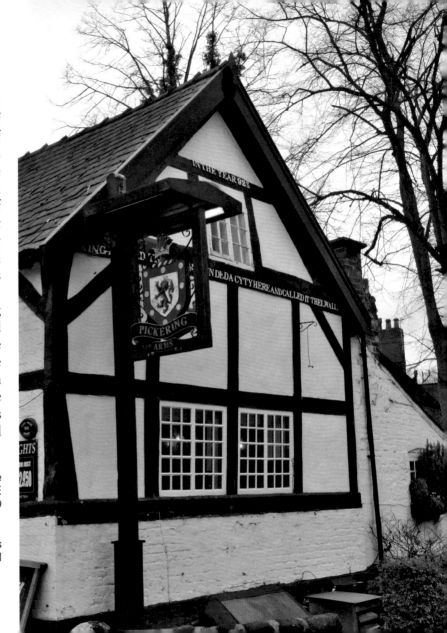

WOOLSTON EYES AND PADDINGTON MEADOWS, WARRINGTON

The area between Thelwall Viaduct and Warrington is a flat expanse of land, through which the river makes various sharp loops and turns before arriving at Howley Weir. There have been several attempts over the years to shorten the course of the Mersey here by eliminating some of the larger loops in an attempt to straighten and deepen the river's course.

Woolston Old Cut was built in 1755 to bypass a loop in the river, and Powder Mill Lock was constructed at its lower end. Woolston New Cut opened on 14 February 1821. Its purpose was to remove yet more loops in the Mersey and, in so doing, it replaced Woolston Old Cut. Paddington Lock was placed at its lower end and Woolston Lock at its upper end. The canal fell into disuse in the 1950s, but it continued to supply water to the Black Bear Canal downstream via an aqueduct over the Mersey. The Black Bear Canal was an 8-mile stretch of waterway, built in 1804, which was designed to enable boats to avoid an awkward tidal stretch of the river between Warrington and Runcorn. Later shortened to link into the newly built Manchester Ship Canal, it remained in use until the 1960s when it was filled in by Warrington Borough Council and turned into a nature trail.

The river here encloses two significant areas of conservation: Woolston Eyes, situated to the east of Warrington near Latchford Locks and the west side of the Thelwall Viaduct; and Paddington Meadows, which is a large area of open farmland close to the centre of the town and enclosed on three sides by a loop of the River Mersey. It is the last remaining waterside grassland in the area.

The entrance to the old Black Bear Canal can still be seen at its junction with the Mersey opposite the Warrington Rowing Club.

The Mersey loops around Woolston Eyes before heading west towards Warrington.

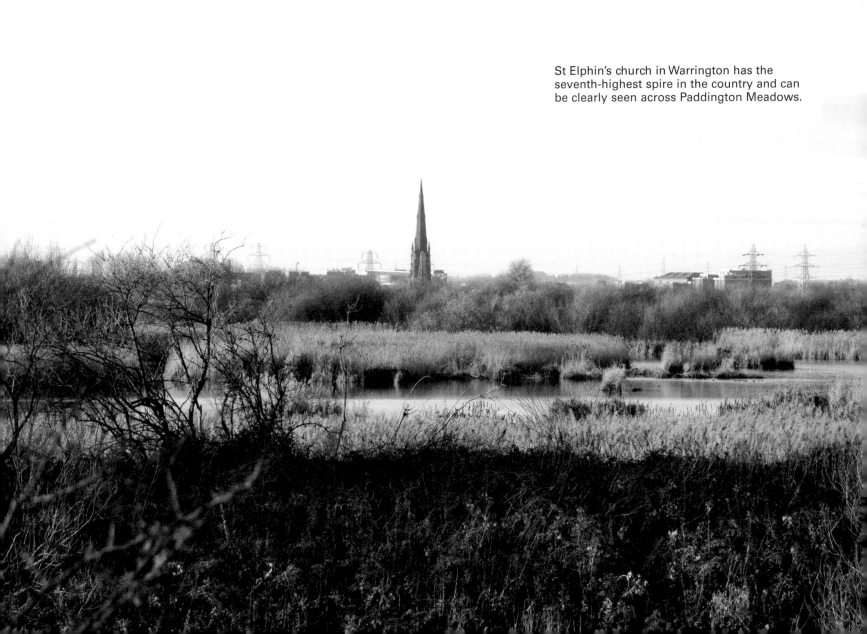

St Elphin's church in Warrington has the seventh-highest spire in the country and can be clearly seen across Paddington Meadows.

HOWLEY WEIR AND VICTORIA PARK, WARRINGTON

The river leaves Paddington Meadows and flows for just over a mile, following the route of the A50 and curving around Victoria Park, before arriving at its tidal point at Howley Weir.

Victoria Park is a large, open space with riverside views. It is built on the site of the Old Warps Estate, which was a residential area of Victorian terraced houses inhabited by people working in local industries. The estate was bought by the local council in 1887 to provide a recreational area for local people, and it was named to celebrate the Diamond Jubilee of Queen Victoria. The Georgian manor house 'Old Warps' still stands and has been converted to a restaurant.

The nature of the park has changed somewhat over the last fifty years. In the 1950s and '60s, the area was a traditional park with a large, stone paddling pool, pavilion, bowling greens and ice cream kiosks. It had managed woodland areas and an abundance of flower beds, adding colour and interest to the pathways. Today, it centres on outdoor activities with a modern sports stadium and skateboard area. One of the attractions of Victoria Park is to walk across the narrow Victorian suspension bridge, which connects Howley and Latchford; this has recently been renovated and brought back to its former glory.

The land for the park had to be reclaimed from the floodplain of the Mersey, and several new weirs were constructed along its length to control the flow of water. The building of Howley Weir, which ensured that the tidal point of the river was established, meant that further stretches towards Manchester could be kept at a constant depth of 8 feet. A short, connecting lock ensured that ships could still bypass the weir and continue their journey east to Manchester.

To the east of the park is the line of the old Black Bear Canal, built in 1804, and one of a series of engineering projects designed to mediate the twists and turns in the river, making navigation safer and more direct.

In the 1960s, Warrington Borough Council bought the land and converted the original stretch of the canal into parkland, with a public footpath forming a route from Victoria Park and the banks of the River Mersey, through to the northern fringes of Stockton Heath. Today, the line of the old canal forms a part of the Trans Pennine Trail.

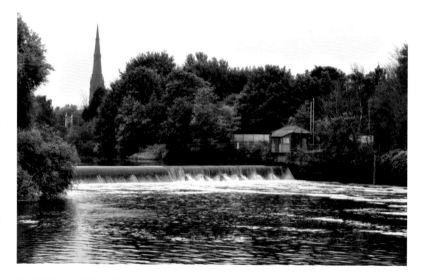

In 1724, the River Mersey underwent massive changes. A series of eight weirs and locks were built to improve navigation up to Manchester. The first of these weirs and locks was situated at Howley. This meant that the river became tidal only as far as Warrington.

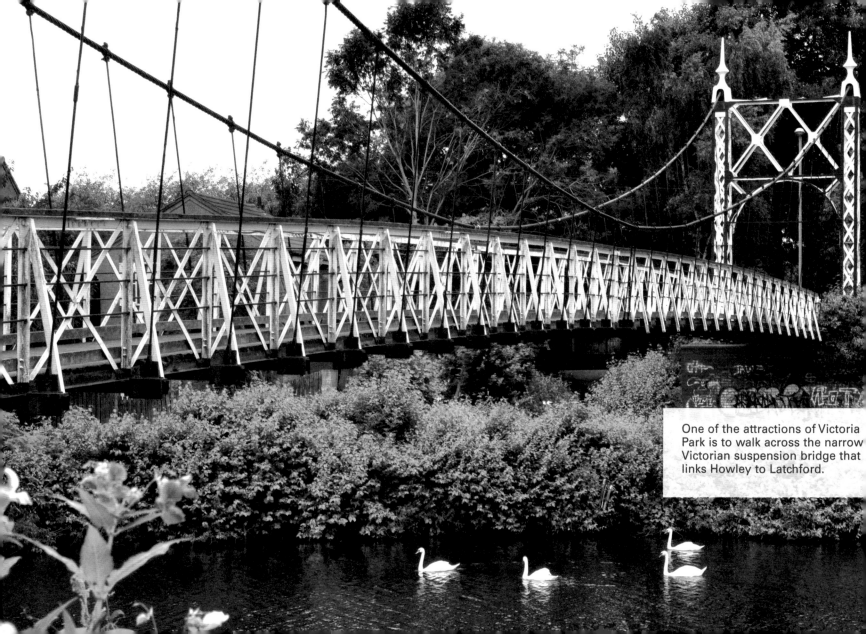

One of the attractions of Victoria Park is to walk across the narrow Victorian suspension bridge that links Howley to Latchford.

WARRINGTON BRIDGE FOOT

The town of Warrington has a particular place in the history of the Mersey. Since ancient times, Warrington has been a major crossing point across the river. Historically, the lowest bridging point on the Mersey was at Warrington, where there has been a bridge since medieval times. There was a Roman settlement at Wilderspool, known as Veratinum, around AD 100, possibly established as a strategic outpost to the major Roman city of Chester, 20 miles to the south.

It was also a major strategic point during the English Civil War with the armies of Oliver Cromwell and the Earl of Derby both laying camp near the old town centre. On 13 August 1651, Warrington was the scene of the last Royalist victory of the Civil War when Scotish troops, under the command of Charles II and David Leslie, 1st Lord Newark, fought John Lambert's Parliamentarians at the Battle of Warrington Bridge.

With the coming of the Industrial Revolution, Warrington expanded into a manufacturing town centred on textile production, chemicals, brewing and steel manufacture. The improvement in the navigational capacity of the River Mersey supported Warrington's expansion and, with the opening of the Manchester Ship Canal and a connection to the railway network, the area continued to grow in prosperity and popularity.

In the centre of the town, the main crossing point is a large, circular traffic island, which crosses the river at Bridge Foot, allowing traffic on the A49 to move freely through the town. This is an extension of the original bridge, an impressive concrete, rib-arched construction that was 80 feet wide and formed a dual carriageway for trams connecting various north–south routes across the town. It was opened by King George V in 1913.

Just south of this point, the river passes under a railway bridge and then a road bridge, which carries Park Boulevard to its junction with Wilderspool Causeway. Excavations in the area have shown Roman settlement, and there are parts of a walled town with evidence of industrial activity.

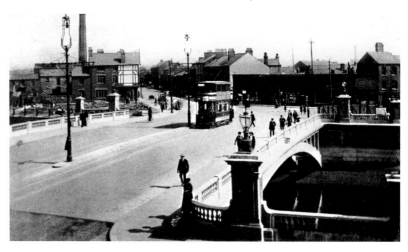

At Bridge Foot, a main crossing point of the river, there is this magnificent single-arched road bridge, Warrington Bridge. This is the sixth bridge on this site. It was opened on 7 July 1913 by King George V, but was not completed until 1915.

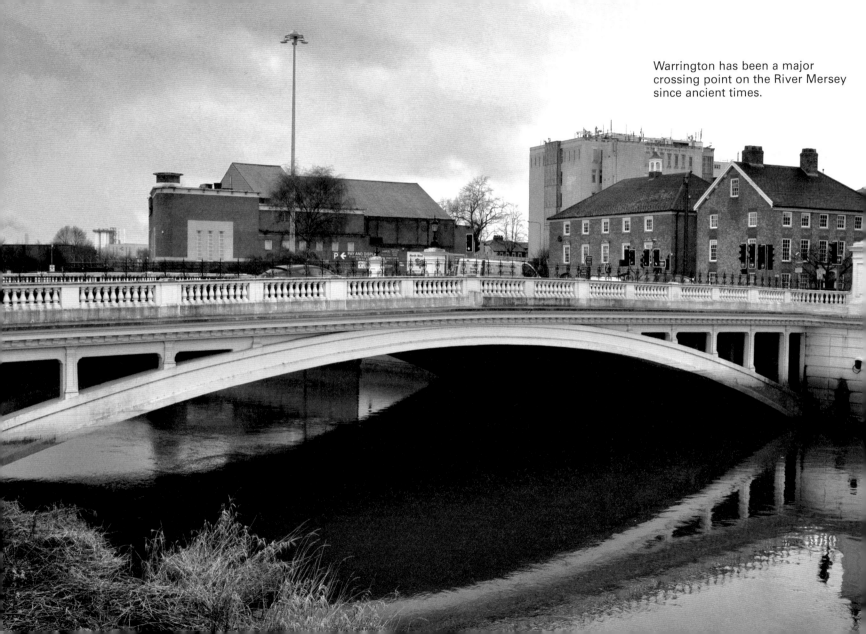

Warrington has been a major crossing point on the River Mersey since ancient times.

WARRINGTON TRANSPORTER BRIDGE

Leaving Bridge Foot, the river reaches the Warrington Transporter Bridge close to the industrial area around Bank Quay station. Hidden away from roads, on private land with difficult access, it is an impressive steel structure with a span of around 61m (200 feet), an overall length of 103m (339 feet) and a clearance of 23m (76 feet) above high-water level.

The bridge was originally built to allow the transport of goods and materials between the chemical and soap works owned by Joseph Crosfield & Sons. William Arrol built the bridge in 1915, using plans provided by architect William Henry Hunter. It opened in 1916, at a cost of £34,000. It was one of two bridges at this location, the other having been built in 1905. It originally carried rail traffic of up to 18 tons in weight between the two works, before being modified in 1940 to accept road vehicles.

Today, the bridge is in fairly poor condition but has been designated by English Heritage as a Grade II* listed building. It is protected as a Scheduled Ancient Monument but remains on their Buildings at Risk register as the ironwork is in a serious state of deterioration. The bridge is preserved under a fifty-year lease in possession of Warrington Borough Council (which expires in 2027). The gondola remains intact.

The River Mersey as it flows under the Eastford Road Bridge and towards Bank Quay. Close by are the remains of the Old Quay Canal.

The River Mersey in a more rural setting, flowing towards Bank Quay, having just passed through Warrington.

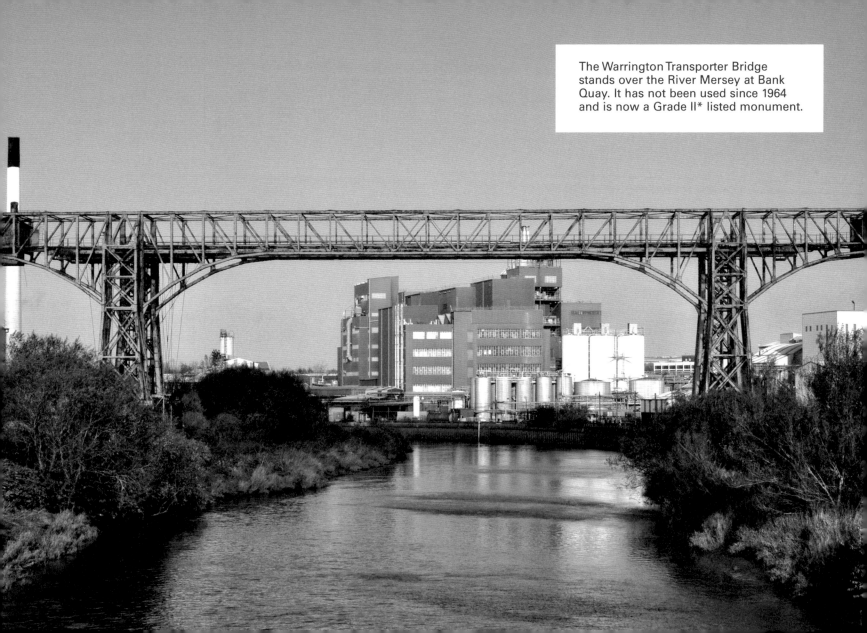

The Warrington Transporter Bridge stands over the River Mersey at Bank Quay. It has not been used since 1964 and is now a Grade II* listed monument.

FIDDLERS FERRY

As the Mersey starts to widen, and the first evidence of tidal sandbanks start to appear, the Sankey and St Helens Canal and the old LNWR line form a tangent with the curve of the river at Fiddlers Ferry. The Ferry Tavern, originally known as the Ferry Inn, is one of Warrington's oldest pubs. On wild winter days, with the wind whipping up the estuary and the dark skies gathering, it is a fine place to enjoy the local ale in the comfort of one of the small rooms warmed by a roaring log fire. The estuary here is prone to tidal flooding, and high water marks can be seen on the bar inside the tavern. The name Fiddlers Ferry dates back to 1160, when the area was named after the owner of Penketh Manor. One of his privileges was the right to establish a ferry over the river, and a ferryman's house was constructed, supplying refreshment to travellers.

Dominating the landscape for miles around, and a short distance downstream from the inn, is Fiddlers Ferry power station. Opened in 1971, it is a coal-powered fire station with eight 114-metre-high cooling towers, which hurl clouds of steam into the skyline visible from as far away as the Peak District, with which it has an unlikely connection. As part of the Beeching Report of 1963, the Hope Valley line was scheduled for closure as it was one of two similar routes linking Lancashire to Yorkshire. The other route, through Woodhead, was considered to be a better route. But British Rail, knowing they would be supplying coal in huge quantities to Fiddlers Ferry, designated this route for freight only and kept the Hope Valley route open as a passenger line. Today it is a busy commuter route linking Manchester and Sheffield and provides travellers with one of the most picturesque rail journeys in England.

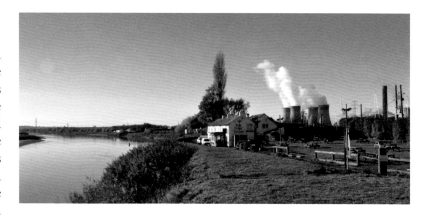

The Ferry Tavern is a popular hostelry for walkers and cyclists exploring the Trans Pennine Trail.

The race marshal overseeing a Sunday afternoon yachting race at Fiddlers Ferry.

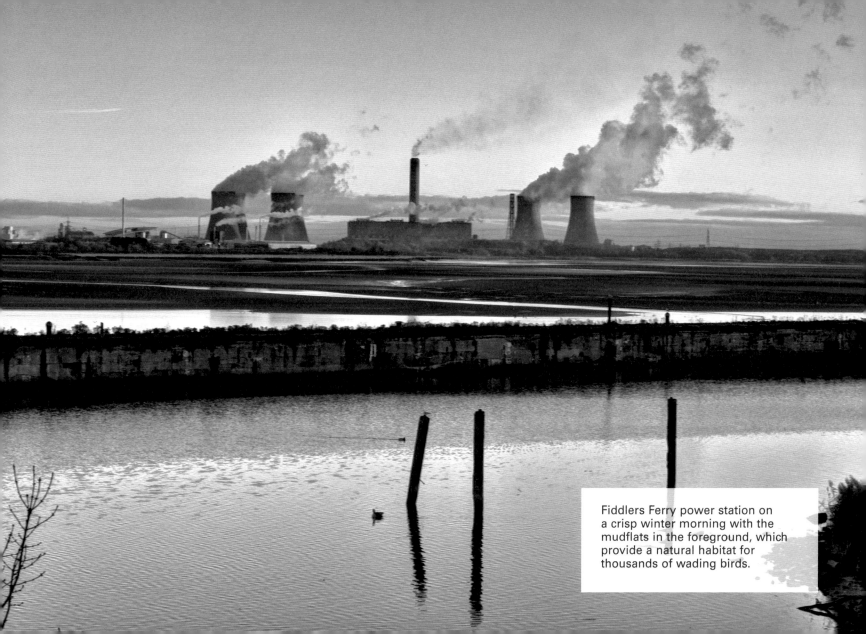

Fiddlers Ferry power station on a crisp winter morning with the mudflats in the foreground, which provide a natural habitat for thousands of wading birds.

THE SANKEY AND ST HELENS CANAL

When it opened in 1757, the Sankey and St Helens Canal connected St Helens with the River Mersey at Sankey Brook near Warrington. Extensions were constructed at the Mersey end of the canal, firstly to Fiddlers Ferry and then to Widnes, but the canal fell into disuse between 1931 and 1963. Since 1985, the Sankey Canal Restoration Society has overseen the restoration of large stretches of the waterway.

Most of the canal still retains water and has been restored to a navigable standard. Sections at Fiddlers Ferry, Warrington, and Spike Island, Widnes, have locks that allow a variety of craft to access the Mersey. However, many of the old swing bridges along its route have been replaced by fixed wooden structures, which isolate sections of the canal from one another. There are plans to extend the canal into the main canal system via the Leeds and Liverpool Canal, but this is seen as a long-term project due to the substantial costs involved.

Behind the Fiddlers Ferry tavern lies an attractive canal marina from which boats can sail and race along the Mersey, accessing the river via the Fiddlers Ferry lock. There is a well-established tradition of yacht racing during high tide, when there is room to negotiate the sandbanks and the wind whips around the sharp bends in the river. Further sections of the canal are currently being restored with the initial aim of opening up the waterway all along to Spike Island, where the original lock gates for the western end of the canal are still operational.

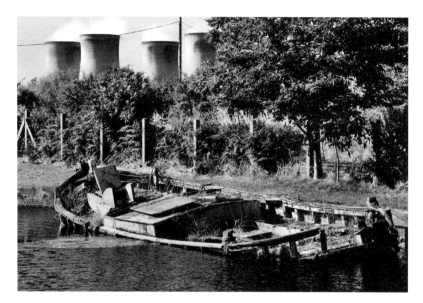

Above right: Some of the vessels along the canal have seen better days.

Right: The entrance to the canal at Widnes still shows the water level in Roman numerals.

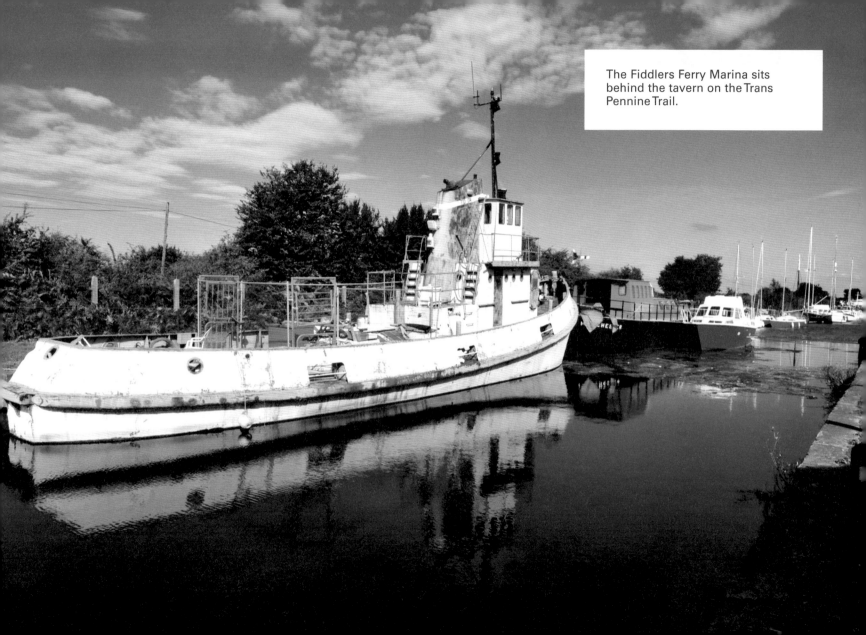

The Fiddlers Ferry Marina sits behind the tavern on the Trans Pennine Trail.

NORTON PRIORY AND HALTON CASTLE

In 1115, a community of Augustinian canons was founded by William Fitz Nigel, the 2nd Baron of Halton, on the south bank of the River Mersey, close to where it narrows to form Runcorn Gap. The reason for its location was that this point in the river was the only practical site where the Mersey could be crossed in the long stretch between Warrington and Birkenhead.

In 1134, his son William Fitz William moved the priory to its present site in Norton, 3 miles east of Runcorn. The reason for the move is unknown, but it may have been that William wanted higher ground to exercise greater strategic control over the area, or simply that the canons wanted a more secluded site.

The priory saw several phases of building and rebuilding over the next two centuries. Today, the ruins are a popular visitor attraction. Much of the original layout of the buildings – the cloisters, church, refectory and dormitory – can be seen, as well as the surviving twelfth-century undercroft, which is an impressive part of the surviving structures.

The priory met its end in April 1536, during the first phase of Henry VIII's Dissolution of the Monasteries, and developed into an overgrown wilderness until Runcorn Development Corporation started its restoration in 1971. Nothing remains of the original site on the banks of the Mersey.

Nearby, on a bluff of red sandstone, stand the ruins of Halton Castle. The castle is a major landmark and has had a variety of usages over the years. John of Gaunt used it as a hunting lodge and, in the mid-1500s, it was used a prison to hold recusants – Catholics who refused to attend Anglican church services and accept Henry VIII as head of the English Church. Before the days of artillery the castle was virtually impregnable, but in the Civil War its Royalist garrison was forced to surrender under an artillery bombardment by the army of Sir William Brereton in 1643.

In its time, the Manor of Halton had many privileges, which included its own prison and a court of justice. One of its customs was that the driver of beasts over a common should pay a halfpenny a-piece to the lord as a fee if he permitted them to graze or take but a thistle. This practice was termed 'thistletake' and still exists as a term documented in Black's Law Dictionary today.

The castle is now in ruins but there is still evidence of strong stone walls, and from within the courtyards its strategic importance is clear, with fine views of the inner and outer estuaries of the Mersey, the Manchester Ship Canal, Frodsham and Helsby Hill and the Welsh mountains.

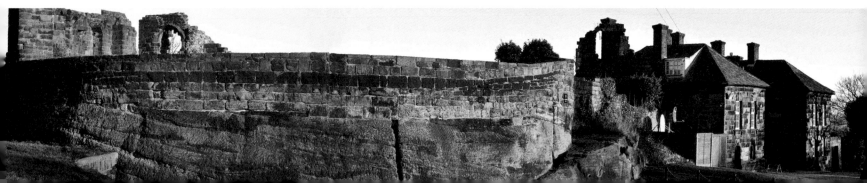

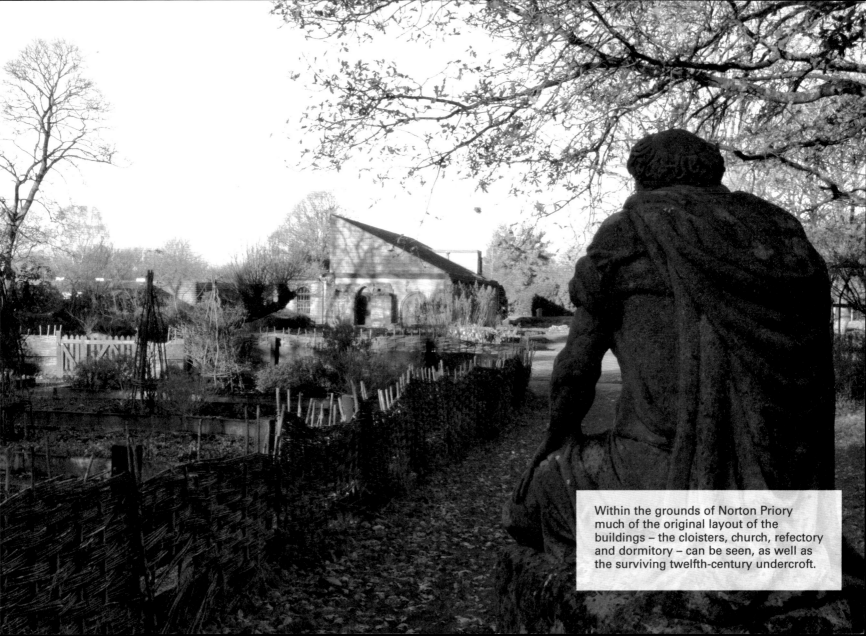

Within the grounds of Norton Priory much of the original layout of the buildings – the cloisters, church, refectory and dormitory – can be seen, as well as the surviving twelfth-century undercroft.

WIGG ISLAND TO SPEKE HALL

As the estuary continues to widen, the river heads towards Widnes and Runcorn, where Runcorn Gap provides the last narrow crossing point before the river reaches the sea. Originally linked by a single ferry, the quest to cross the gap has manifested itself in different guises over the years, with the building of the Ethelfleda Railway Bridge in 1868, the Transporter Bridge in 1905, and the Jubilee Road Bridge in 1961.

At Widnes, the Victoria Promenade at West Bank, which runs alongside the River Mersey and Spike Island, is now cleared of industry and forms an open recreational area, leading to footpaths along the former towpath of the Sankey and St Helens Canal.

Before the building of Railway Bridge and its attached footbridge, the only way to cross the Mersey at or near Runcorn Gap, other than by the dangerous method of negotiating the mudflats at low tide, was by ferry. The use of a ferry at this point dates back to the twelfth century, and 'The Runcorn Ferry', a famous monologue written by Marriott Edgar, was popularised by Stanley Holloway. It includes the repetitive lines:

Per tuppence per person per trip...
Per trip or per part of per trip.

To the west of Widnes, the Trans Pennine Trail wends its way towards Hale village through Pickerings Pasture at Halebank. To the west of this point is the Hale Duck Decoy, a Scheduled Ancient Monument owned by Hale Estates and administered by Halton Borough Council. The decoy covers an area of 5 acres and is surrounded by a moat crossed by a swing bridge. Within its irregular pentagon it contains a central pool with five pipes radiating from it. Built within the decoy is a gamekeeper's cottage. The exact date of its construction is not known, but there is evidence that it was built sometime in the seventeenth century.

As the river exits the narrows and flows into the inner estuary, the lighthouse at Hale shore stands as a reminder that ships once needed protection to navigate this point. Across the river, the Manchester Ship Canal now carries the traffic from Eastham Locks, running parallel with the Mersey towards Manchester.

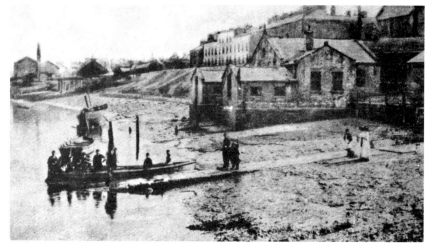

Right: Before the building of the bridges, the only way to cross the Mersey was by a ferry service. This late nineteenth-century photograph shows passengers boarding the ferry to make the tricky journey from Runcorn to Widnes.

Below: The bridge's lights illuminate the streets around West Bank during the evening.

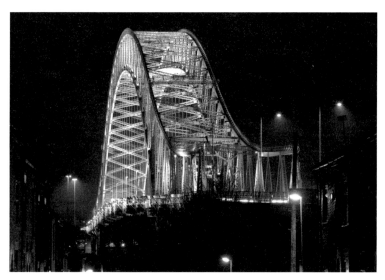

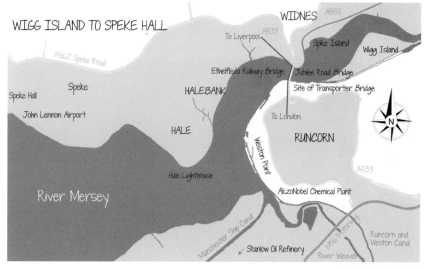

WIGG ISLAND TO SPEKE HALL

SPIKE ISLAND AND WIGG ISLAND COMMUNITY PARK

A short distance from the power station, on the northern bank of the river, is Spike Island, a plug of land between the Mersey and the point where the Sankey and St Helens Canal merges with the river.

In 1833, the newly constructed St Helens & Runcorn Gap Railway connected St Helens with an area in Woodend, which was to become known as Spike Island. The canal and railway ended here at Widnes Dock, which was the first railway dock in the world.

Spike Island played a major part of the development of the chemical industry in Widnes as it was the place where many of the factories producing the most toxic chemicals and by-products were situated. With the decline of the industries, the site was left to deteriorate and, by the 1970s, was a toxic wasteland of old railway sidings, ruins of abandoned factories, and old canal and dock debris set in a polluted wilderness devoid of all vegetation. However, between 1975 and 1982, it was reclaimed as woodland, wetlands and green recreational space, and today is a pleasant place to stroll, picnic or feed the growing population of swans that have taken up permanent residence alongside the canal boats and small sailing vessels on the Sankey and St Helens Canal.

Wigg Island Community Park is a nature reserve on the opposite southern bank, sandwiched between the River Mersey and the Manchester Ship Canal. The Visitors' Centre is a green building constructed using sustainable techniques that minimise its impact on the environment, and has a wind turbine that supplies carbon-free electricity.

Like Spike Island, it can be considered to be a triumph in industrial land reclamation and rejuvenation, as it was a heavily polluted industrial site before it was decontaminated and reopened. During the Second World War, Wigg Works East, under its old name of Randles Works, engaged in the production of mustard gas – used extensively in the First World War – which formed large blisters on exposed skin and in the lungs. Chemical manufacturing ended at Wigg Island in the 1960s and the site is now administered by the Cheshire Wildlife Trust and supported by the Friends of Wigg Island organisation. Covering around 23 hectares, it has developed into a popular bird-watching environment and supports an abundance of rare native wildflowers.

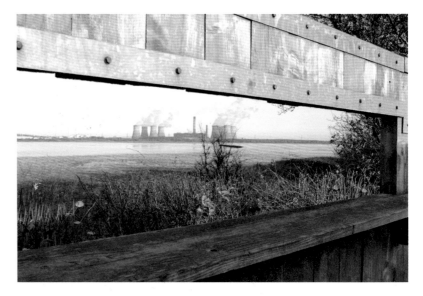

Well-constructed bird hides are a feature of Wigg Island's trails and allow clear views of the estuary and the thousands of birds, that winter on the wetlands.

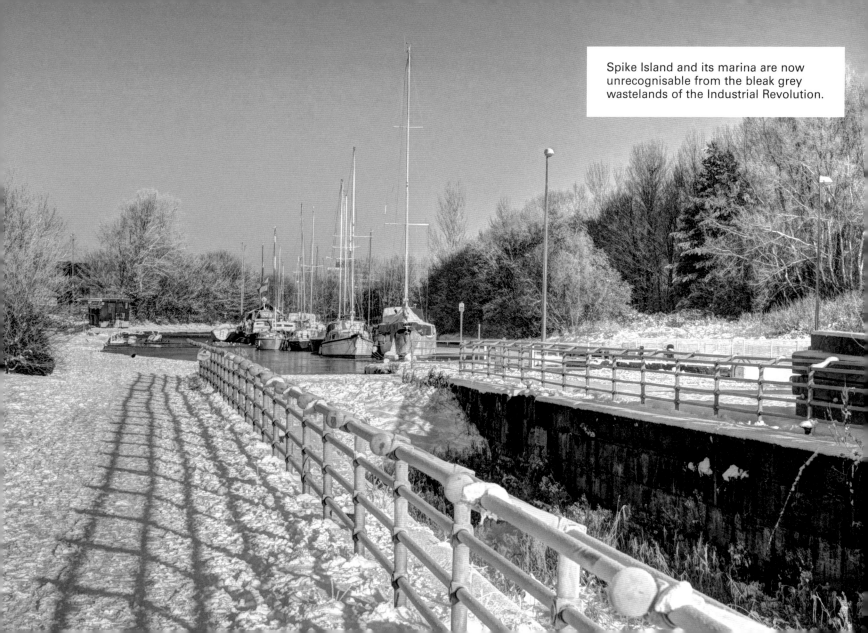

Spike Island and its marina are now unrecognisable from the bleak grey wastelands of the Industrial Revolution.

RUNCORN AND RUNCORN GAP

The town of Runcorn sits south of Widnes at a point known as Runcorn Gap. The Bridgewater Canal terminates in the canal basin in the town centre, as the locks leading down to the Ship Canal were filled in some years ago.

Until the coming of the Industrial Revolution, Runcorn was a small, isolated village on the banks of the river with poor transport links. In the late eighteenth and early nineteenth centuries, it had a reputation as a health resort famous for its fresh air and clean riverside walks. Sailing on the river was popular and the estuary would be alive with small yachts, their skippers pitting their skills against the swirling currents and strong winds. However, with its development as a port, the industries of soap and alkali manufacturing, quarrying, shipbuilding, engineering and tanning all developed in the town and industrialisation changed its nature completely.

The neighbouring villages of Halton and Weston, which sit in elevated positions to the south of the town, have to some extent retained their semi-rural character and are characterised by attractive sandstone buildings, with fine views across the Mersey Estuary and the Cheshire Plain.

Most of the old industries have now disappeared, but the neighbouring motorway system has led to the development of warehousing and distribution centres, which form the basis for employment in the town. A new town was built to the east of the existing town in the 1960s and '70s to provide housing estates for its growing population. Along the foreshore, in the old town, new riverside developments are springing up to take advantage of the cleaner environment and panoramic views along the estuary.

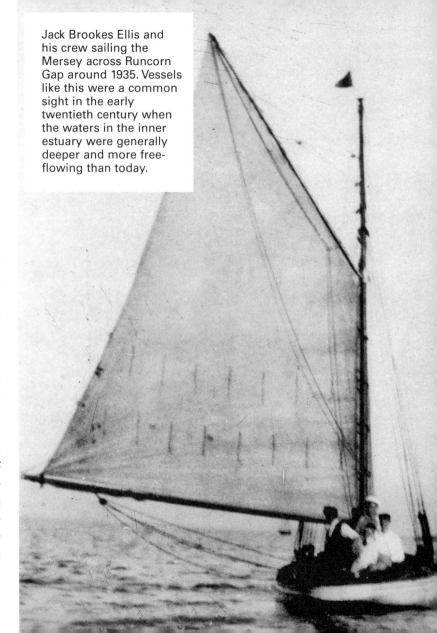

Jack Brookes Ellis and his crew sailing the Mersey across Runcorn Gap around 1935. Vessels like this were a common sight in the early twentieth century when the waters in the inner estuary were generally deeper and more free-flowing than today.

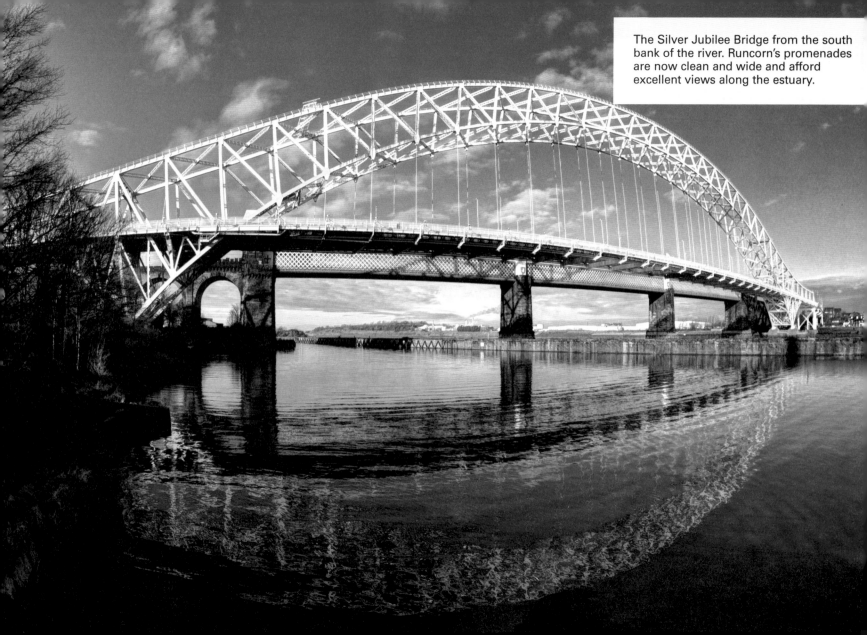

The Silver Jubilee Bridge from the south bank of the river. Runcorn's promenades are now clean and wide and afford excellent views along the estuary.

WIDNES AND WEST BANK

The chemical industry developed seriously in Widnes with the building of John Hutchinson's factory on land between the Sankey and St Helens Canal and the railway in 1847. Its proximity to river and rail links made Widnes an ideal site for industrial development, and entrepreneurs such as John McClelland, William Gossage, Frederic Muspratt, Holbrook Gaskell and Henry Wade Deacon soon established further factories nearby. The result of this development was that the town became heavily polluted, particularly from the Le Blanc bleaching process. Industrial waste including soap, borax, soda ash, salt cake and bleaching powder poured into the river, and clouds of toxic black smoke shrouded the town to the extent that by 1888 the town was described by many writers as the dirtiest, ugliest and most depressing town in England – a poisonous hellhole where no sensible human being would want to live.

From out of this industrial purgatory, however, grew the community of West Bank, which was situated on a plug of land on the north bank of the river and consisted of a crisscross of back-to-back terraces, corner shops, churches and pubs. It was a community of workers and their families who supported each other unwaveringly in the face of living in surroundings dominated by a landscape of factories, dockyards, railway sidings, chemical waste tips and a river so heavily polluted that its colour changed continually as the reds, blues and yellows of chemical by-products were absorbed by the slow-moving, sludge-filled waters.

A photographic record of this community is documented in Fiona Jenkins' excellent book, *Images of West Bank*, published by the West Bank Heritage Project in 2005. In the introduction,

West Banker Jack Ashley, Baron Ashley of Stoke, describes the unique social fabric of this area, which was built on successive generations of families who lived and stayed in the community. Some of the terraces still remain, but much of the area has been redeveloped with modern, low-cost housing. The streets are now clean and the factories have gone. John Hutchinson's Tower Building, once the administrative centre for his alkali business, is now a museum, housing the Catalyst Science Discovery Centre, which charts the rise of the chemical industry in Widnes and how it shaped the lives of working families for decades.

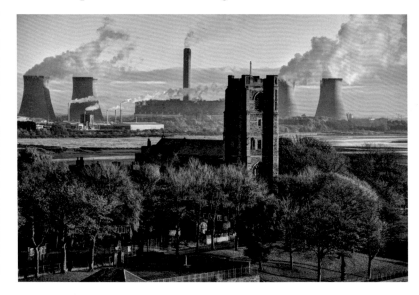

St Mary's church, in the heart of West Bank, has stood proudly on the banks of the Mersey since 1910 and is an English Heritage Grade II* listed building.

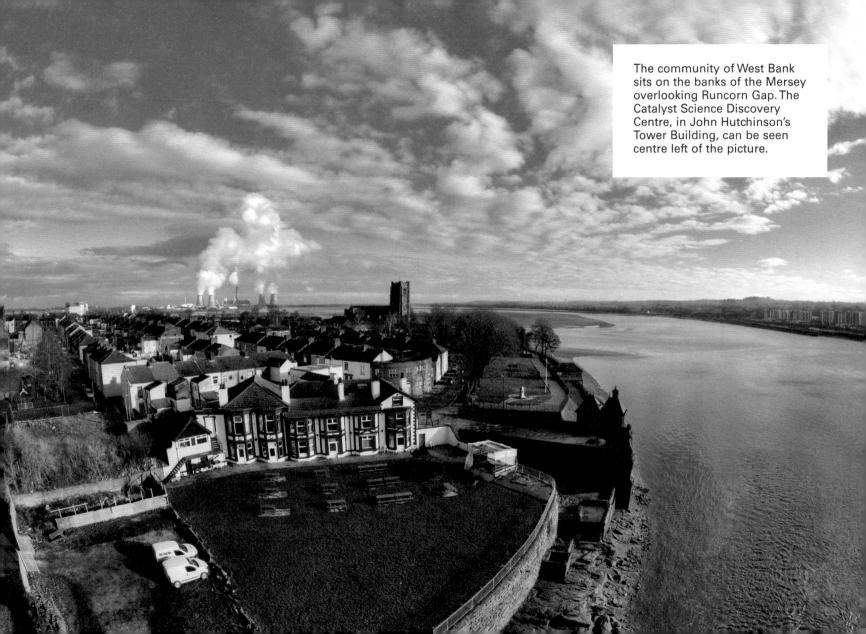

The community of West Bank sits on the banks of the Mersey overlooking Runcorn Gap. The Catalyst Science Discovery Centre, in John Hutchinson's Tower Building, can be seen centre left of the picture.

THE WIDNES-RUNCORN SILVER JUBILEE BRIDGE

The planning of a road bridge across the Mersey at this point was far from straightforward. The idea for a high-level bridge, with a 24-foot-wide carriageway was abandoned because of the expense. Aerodynamic problems caused by the adjacent railway bridge put paid to the proposed design of a suspension bridge with two towers, a single carriageway and footpaths. The final design of a single steel arch bridge, which would be strong enough to avoid aerodynamic problems caused by the adjacent railway bridge, was finally accepted and work commenced on 25 April 1956.

The construction of the bridge had serious repercussions for the community of West Bank. To the east of the community, several streets were cleared to make way for the approach roads and the residents moved out to new housing developments to the north of Widnes. Remaining residents were subjected to five years of noise and environmental pollution to add to that already provided by the significant number of chemical works that were still operating nearby. The new approach road sliced the eastern side of the community away, taking with it some buildings of real architectural merit such as the Bridge Hotel, which had been central to the community for many years.

The new bridge was opened on 21 July 1961 by Princess Alexandra, but by 1975 it had to be widened to accommodate the trebling of traffic that had occurred over the previous ten years. In 1977, it was renamed the Silver Jubilee Bridge to commemorate twenty-five years of Queen Elizabeth II's reign. It now handles around 80,000 vehicles per day and, in order to alleviate severe periods of congestion, the building of a further crossing is planned, which will be known as the Mersey Gateway.

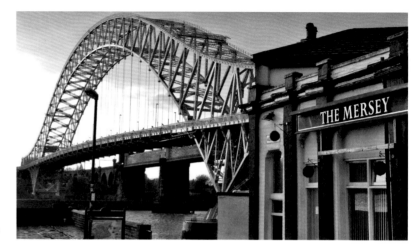

The Mersey Hotel sits underneath the Silver Jubilee Bridge on the Widnes side. It is still known to locals as 'The Snig', a name that originated from the pies that it used to serve made from 'snigs', a local word for eels.

The Bridge Hotel (also known as The Round House because of its shape) was one of a number of buildings pulled down to make room for the Silver Jubilee Bridge approach road.

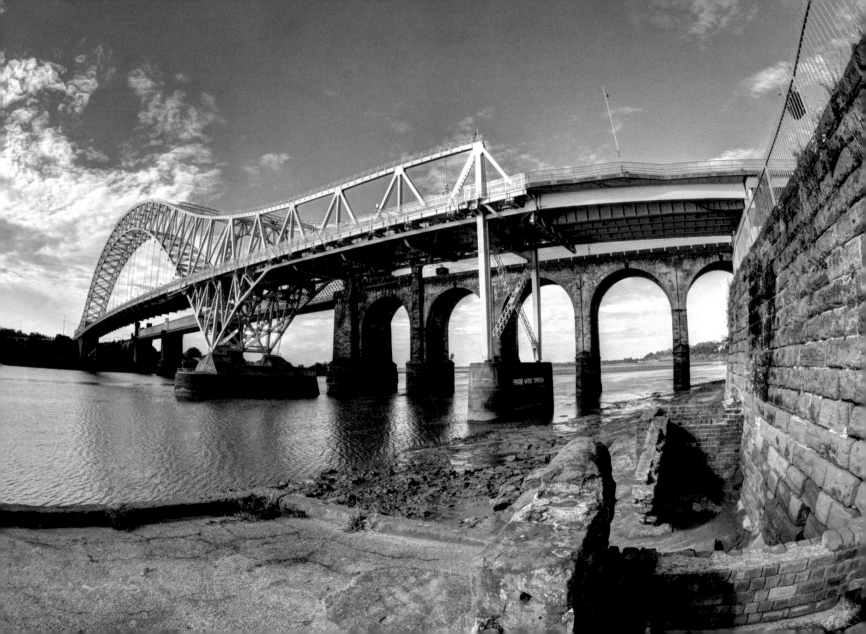

THE ETHELFLEDA BRIDGE

The Ethelfleda Bridge was completed in 1868, and opened to rail traffic in 1869, providing a route for passenger and goods services south from Liverpool and also a walkway, which allowed residents from Runcorn and Widnes to gain pedestrian access between the towns.

The walkway was a flimsy affair that ran along the side of the line and pedestrians were clouded in steam and ash with the passing of each train. Part of the walkway was constructed of wooden slats, which would occasionally loosen and form gaps wide enough to provide any unsuspecting pedestrian with a vertical route down into the swirling waters of the Mersey, which waited some 75 feet below. It was closed for safety reasons in 1965.

Locally, the bridge is known as the Ethelfleda Bridge (named after Ethelfleda, the eldest daughter of Alfred the Great), as the southern abutments and pier are built on the site of a Saxon burh erected by her in 915. There is no doubt that the Mercian princess would have had good reason to build defences here, as it would have given her an ideal defensive position from which to repel the boats of the invading Danes.

However, it is more commonly known as the Britannia Bridge, and there are three shields above the southern end of the footway showing the coat of arms of the City of London, the Liver Bird of Liverpool and Britannia herself, taken from the crest of the railway company. Today, the bridge handles significant amounts of traffic from Liverpool to London on the branch of the West Coast Main Line.

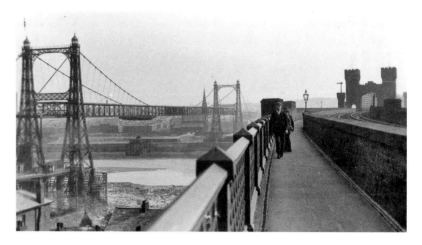

The walkway across the bridge was well used by pedestrians crossing the river up until its closure in 1965.

The Ethelfleda Bridge incorporated some imaginative building projects during its construction. Today, the Runcorn Spiritualist church worships to the sound of inter-city trains passing overhead.

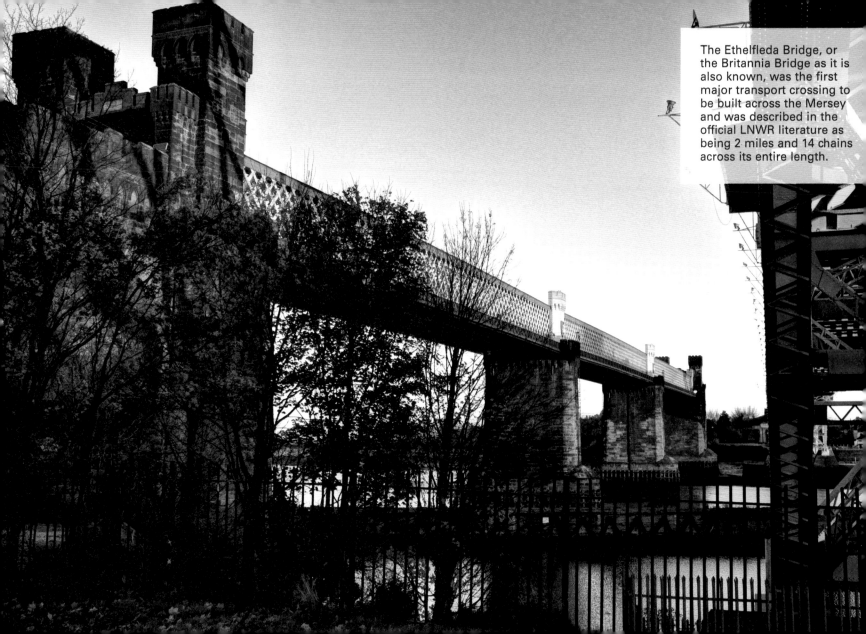

The Ethelfleda Bridge, or the Britannia Bridge as it is also known, was the first major transport crossing to be built across the Mersey and was described in the official LNWR literature as being 2 miles and 14 chains across its entire length.

THE WIDNES-RUNCORN TRANSPORTER BRIDGE

Before the Transporter Bridge was constructed, the only means of getting across the Mersey was via a pedestrian footpath, included as part of the structure of the railway bridge, or by a rowing boat ferry. With the construction of the Manchester Ship Canal, passage by ferry became a difficult journey as passengers had to alight from one boat halfway across, scale the wall of the Ship Canal, and descend into another vessel on the other side. In the early twentieth century, the building of a road bridge was considered but the cost of constructing an elevation high enough to allow sailing vessels to pass underneath was deemed too prohibitive. The building of the Transporter Bridge provided an adequate solution in that the passage of the suspended deck could be timed to allow vessels to pass through the substantial metal structure that supported it. Designed by John Webster and John Wood, and taking four years to build, the bridge was opened by Sir John Brunner on 29 May 1905.

The Transporter had two distinctive towers at either end of the span. They were 180 feet in height and the span across the Mersey was around 1,000 feet. Suspended from the cables was the transporter car, a box-like structure that was capable of transporting a small number of vehicles and several passengers across the river, the journey taking approximately two and a half minutes. The car had a driver who was stationed in a small cab on top of the structure with a clear view in all directions. The clearance above the water line was not great, being only 12 feet at high tide, and it was not unusual for enterprising swimmers to drop from the cab into the ship canal and spend a few minutes enjoying the short swim to Runcorn shore.

With the opening of the high-level road bridge in 1961, the Transporter Bridge ceased service and its deteriorating ironwork structure was subsequently demolished. The approach roads to the bridge still remain on both sides of the river and, on the Widnes side, the power house still stands and is a Grade II* listed building overseen by English Heritage. The former office building, Transporter House, also remains and is at the end of Mersey Road opposite the Mersey Hotel.

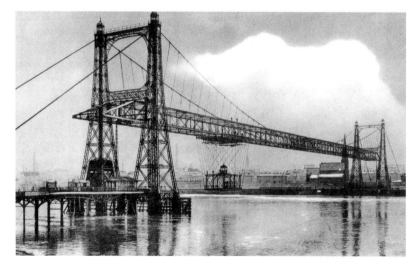

Above: The bridge was erected for the Widnes & Runcorn Bridge Company by the Arrol Bridge & Roof Company of Glasgow. It was designed by J. J. Webster and J. T. Wood and was completed in 1905 at a cost of £130,000.

Opposite: The transporter power house building still sits at the end of Mersey Road, which, at one time, would have been jammed with traffic waiting to make the crossing.

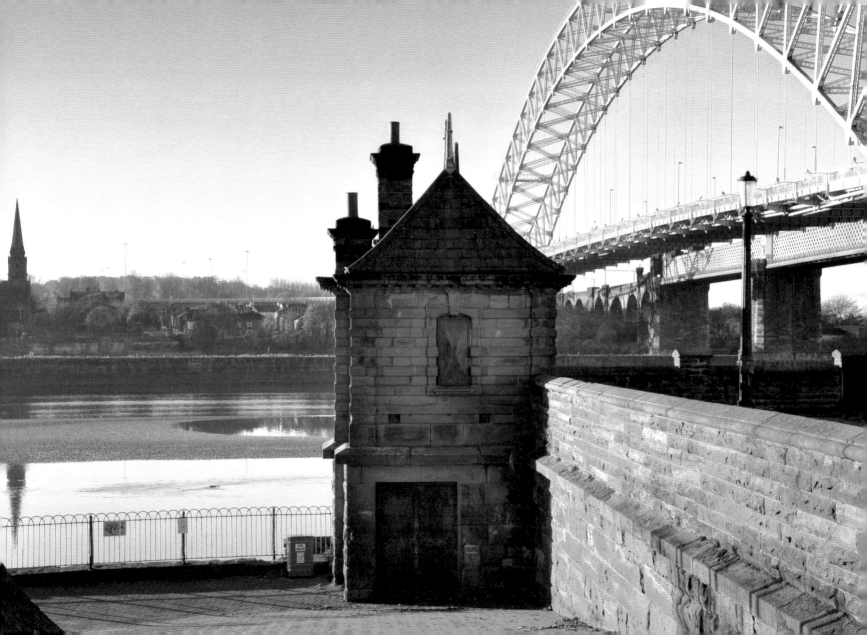

WESTON POINT AND STANLOW

A view across the Outer Estuary looking south takes in the heavy industrial landscape of AkzoNobel and the Stanlow oil refinery. To the casual observer, the AkzoNobel's chemical works, sandwiched between the rocky heights of Weston Point and the last throes of the River Weaver before it enters the Manchester Ship Canal, presents a fearsome landscape. It presents, as one continual development, a seemingly endless series of inter-connecting metal tubes, white-domed containers and chimneys stretching around the western edge of Runcorn. At night it changes into a mesmeric complex of lights. Viewed from the quieter shores of Hale, it is a futuristic cityscape plucked from the world of Fritz Lang or George Lucas; its reflection shimmers in the Mersey Estuary as the production of paints and coatings continues around the clock.

AkzoNobel ended an eighty-one-year association with ICI in Runcorn in 2007. The company left its mark in the streets around Weston Point. Mather Avenue, Roscoe Crescent and Castner Avenue were the first residential roads built by the company, and from the air spell out the initials of 'ICI'.

Stanlow Refinery, a short distance along the river, occupies a large area of the southern bank of the river. It has been on the same site since 1924, when a small plant specialising in the production of bitumen first opened. Oil has been pumped in from tankers since the 1970s, when a pipeline stretching from Amlwch in Anglesey to Stanlow was constructed. Some oil still arrives via the UK oil pipeline network, by road, and from tankers using the Manchester Ship Canal.

The refinery continues to flourish and immediate plans for the future include an increase in the manufacturing of diesel and aviation fuel. The refinery dominates the landscape for a 4-mile stretch of the river, offering a bleak landscape of chimneys, storage tanks and pylons for travellers along the river or the residents of Thornton-le-Moors, a small village on its southern edge.

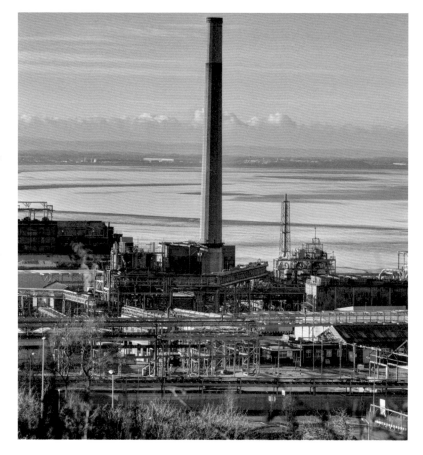

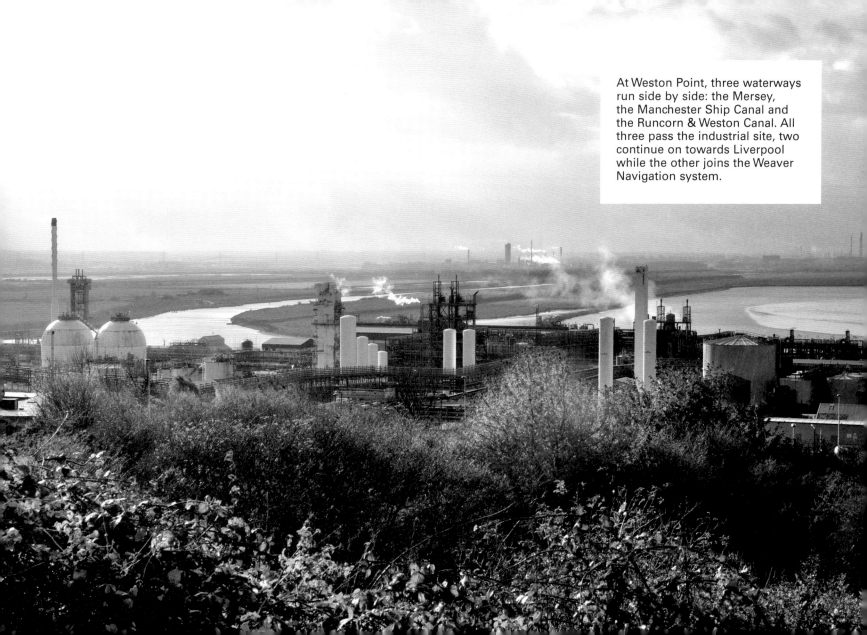

At Weston Point, three waterways run side by side: the Mersey, the Manchester Ship Canal and the Runcorn & Weston Canal. All three pass the industrial site, two continue on towards Liverpool while the other joins the Weaver Navigation system.

HALE LIGHTHOUSE AND HALE VILLAGE

As the river bends sharply, it touches the heavy industry of Frodsham shore, widening after the constriction of Runcorn Gap. Directly opposite, on the northern bank of the Mersey, sits the village of Hale. It is almost as if one of the picturesque villages of Cheshire has somehow been transported and positioned in juxtaposition with the miles of metal structures on the opposite bank. Hale Lighthouse was originally built in 1906 and is 45 feet high. It sits proudly on the sandstone cliffs, with its whitewashed needle pin tower pointing to the sky. When it was operational, the light could be seen from as far as 40 miles away. It was decommissioned in 1958 and the original lamp now resides in the Merseyside Maritime Museum at the Albert Dock.

Hale's most famous inhabitant was John Middleton, the Childe of Hale. Legend says that even before his twentieth birthday, he had reached the height of 9 foot 3 inches. John died on 23 August 1623 and his grave can be found in St Mary's churchyard. In the village, his whitewashed cottage still stands today and has recently undergone renovations after some years of neglect. In the gable end of the cottage are two windows, and the story goes that at night his two feet could be seen protruding through the open casements, as the room in which he slept was too small to accommodate his considerable frame.

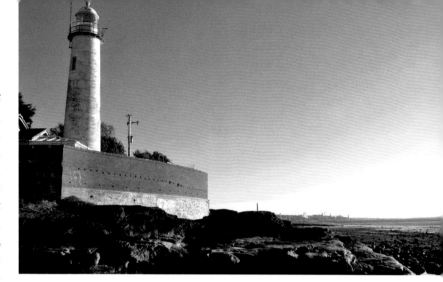

Above right: The tower is 45-foot-high; even with it being so small, the lamp's beam could be seen from as far away as 40 miles.

Right: John Middleton, the Childe of Hale, reached the height of 9 feet 3 inches. In Hale village, his whitewashed cottage still stands today.

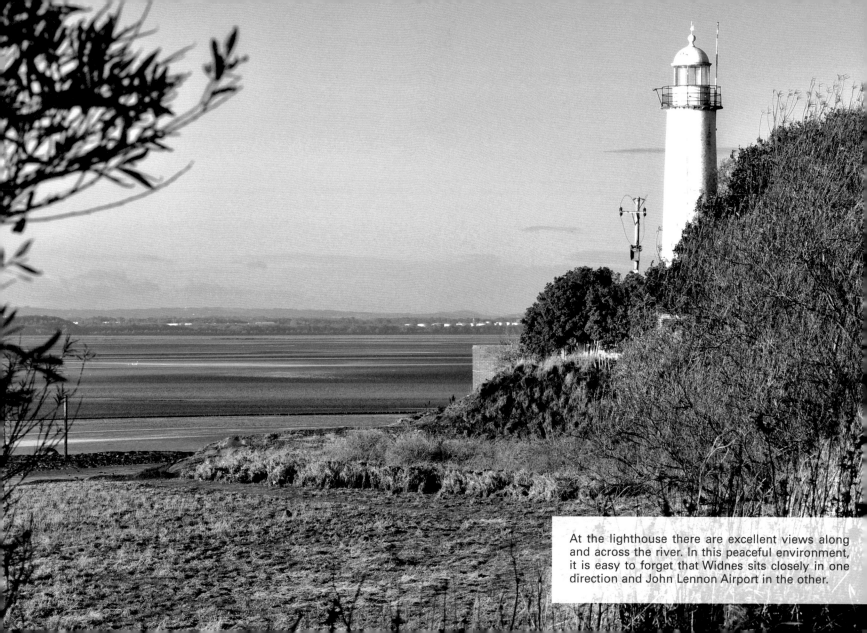

At the lighthouse there are excellent views along and across the river. In this peaceful environment, it is easy to forget that Widnes sits closely in one direction and John Lennon Airport in the other.

JOHN LENNON AIRPORT

Just over one mile from the centre of Hale Village is the eastern edge of the runway of John Lennon Airport. Originally known as Speke Airport, it started scheduled flights in 1930. During the Second World War it was taken over by the Royal Air Force and renamed RAF Speke. It became John Lennon Airport in 2002.

One of its most famous moments during the war came on 8 October 1940 when it witnessed arguably the fastest encounter between German and British air forces throughout the whole of the Second World War. Three German Junkers were spotted approaching Liverpool, and three pilots, Flight Lieutenant Gillam, along with two Polish pilots, Alois Vašátko and Josef Stehlík, took off immediately and engaged the enemy even before they had retracted their undercarriages. The Junkers were shot down and crashed onto the Wirral side of the Mersey. Flight Lieutenant Gillam was back on the runway only a few minutes after he had taken off. He immediately took his car and drove at speed through the Mersey Tunnel, arriving at a crash site just as the surviving German crew members were being rounded up. Jumping from his car, he cut the German badge off the side of the plane, together with one of the swastikas, and drove back to Speke with his souvenirs.

After the war, Speke hosted an annual air display to support injured members of the armed forces, and these proved immensely popular. However, in 1956, disaster struck. On 21 May, Léon Alfred Nicolas Valentin, known as 'The Birdman', visited the air show performing under his professional name of 'Valentin, the Most Daring Man in the World'. Born in 1919 in Épinal (Vosges), France, he always had a keen interest in aviation and his stated ambition in life was to fly like the birds. After a wartime career in the French paratrooper service, he continued to pursue his ambition of bird flight, and claimed that he had managed to fly for 3 miles using a set of wooden wings.

His brief for the show was to leap from a circling plane high above Speke and swoop to the ground using a specially designed set of balsa wood wings. However, on exiting from the plane, one of his wings struck the fuselage and he was cast out into an uncontrollable spin. In panic he deployed his emergency parachute but this only wrapped around him like a cocoon and he plunged to his death in front of 100,000 horrified spectators. He was buried with full military honours at church of Saint-Sauveur, Haute-Saône, on 3 June 1956.

After being left derelict for over a decade, the original terminal building was renovated and turned into a hotel. It is famously seen on the archive black and white newsreels, packed with teenage girls welcoming The Beatles home.

SPEKE AND SPEKE HALL

At the eastern tip of the runway lies the National Trust property of Speke Hall. Speke Hall is a rare Tudor timber-framed manor house, set on the banks of the River Mersey. As well as the preserved house and gardens, there are designated footpaths that lead down to the estuary, affording fine views of across to the Welsh hills and pedestrian access to Liverpool Sailing Club, whose impressive modern boathouse is connected to the river by a concrete slipway.

Built by the devout Catholic Norris family, keen to impress visitors with the grandeur of their home and in particular the magnificent Great Hall, this beautiful building was fully restored to its former glory in the nineteenth century and is a mixture of Tudor simplicity and Victorian Arts and Crafts. The hall has witnessed more than 400 years of turbulent history; from the Tudor period, through years of neglect and decay in the eighteenth and nineteenth centuries (including a spell when it was used as a cow shed) to being renovated in the Victorian era of improvement and technology.

It is rumoured that various ghosts have taken residence within the Tudor mansion. Visitors have reported dark shadows drifting around the Great Hall, and an overwhelming sense of oppression is often felt by those who have the courage to linger and look for explanations.

The Blue Room is also reported to produce similar feelings, and a dark shadowy figure, who has been known to whisper the words 'get out' is one of the most frequently reported sightings. Footsteps are frequently heard in the upper corridors in the dead of night when all visitors have left. The disturbing sound of children crying is also a frequent occurrence, echoing through the empty hall.

The story of Speke's most famous ghost is well known. Rather than cope with her husband's mounting debts and gambling problems, Mary Norris is said to have thrown their young son out of the window in the Tapestry Room into the moat below. In a fit of remorse, Mary then threw herself out of the window and, since then, her ghost has been seen in the Tapestry Room, gliding across the floor, before disappearing through the walls.

Today, Speke Hall, and its surrounding estate, is protected from the industrial development of nearby Speke and Garston, sitting in beautifully restored gardens and protected by a collar of woodland.

The Liverpool Sailing Club is located in the Garston Coastal Park, just behind Speke Hall, and its 1,000-foot slipway gives the only true access to the River Mersey from the north shore.

Speke Hall sits in a tranquil setting on the banks of the River Mersey. It is a unique and vibrant mixture of Tudor simplicity and Victorian craftsmanship.

THE WIRRAL SHORELINE

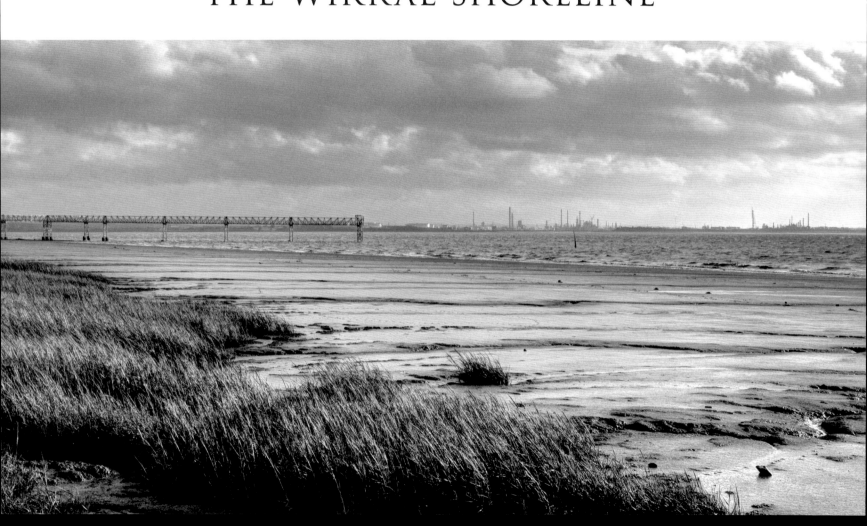

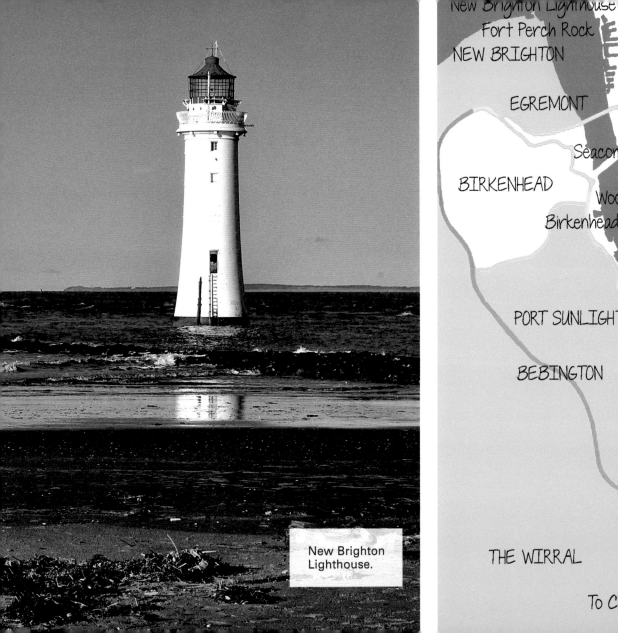

New Brighton Lighthouse.

THE WIRRAL SHORELINE

New Brighton Lighthouse
Fort Perch Rock
NEW BRIGHTON

EGREMONT

Seacombe Ferry

BIRKENHEAD

Woodside Ferry

Birkenhead Priory

N

PORT SUNLIGHT

BEBINGTON

River Mersey

Eastham Ferry

EASTHAM

Queen Elizabeth Dock

THE WIRRAL

National Water Museum

To Chester

ELLESMERE PORT

EASTHAM FERRY, VILLAGE AND COUNTRY PARK

Eastham is identified as one of the oldest villages on the Wirral Peninsula, and there has been a settlement there since Anglo-Saxon times. From the banks of the Mersey, there are spectacular views across the estuary to Otterspool, the dockside buildings of the Pier Head and both the Anglican and Catholic cathedrals. A ferry service has operated across the River Mersey between Eastham and Liverpool since the Middle Ages, with the early ferries being run by monks from St Werburgh's in Birkenhead. It was not unusual for the crossing to take four hours, with more than an element of danger as the oarsmen negotiated the swirling currents and sandbanks of the estuary. In 1846, the owner of the ferry, Thomas Stanley, built the Eastham Ferry Hotel and, shortly afterwards, the Eastham Pleasure Gardens, which were designed to attract more visitors.

There were several attractions for the visitors, including beautifully landscaped gardens, which contained a zoo with bears, lions, monkeys and an antelope. There was also a bear pit where Victorian gentlemen could gather and enjoy the 'sport' among gardens that contained a variety of exotic plants, ornamental trees and fountains. There was an open-air stage, tea rooms, a bandstand, a ballroom, a boating lake and a water chute. With the coming of the Manchester Ship Canal in 1897, even more visitors flocked to the area and a Jubilee Arch was built at the entrance to the pleasure gardens to commemorate the Queen's Diamond Jubilee. At the height of its popularity, Eastham Ferry was known as the 'Richmond of the Mersey'.

However, its popularity declined during the 1920s and the last crossing took place in 1929, after which the original ferry was closed. The gardens, however, remained and in 1970, to commemorate European Conservation Year, it was designated a Woodland and Country Park. Today, it is a popular place of recreation, providing riverside walks and opportunities for bird watching across the expansive wild stretches of the estuary.

Above: The old Eastham Ferry ticket office stands near to what remains of the ferry jetty. It was built in 1857. The 'office' now serves light refreshments.

Opposite: An oil tanker queuing to enter the Queen Elizabeth II Dock, which is adjacent to the entrance to the Manchester Ship Canal. The oil dock was opened on 19 January 1954.

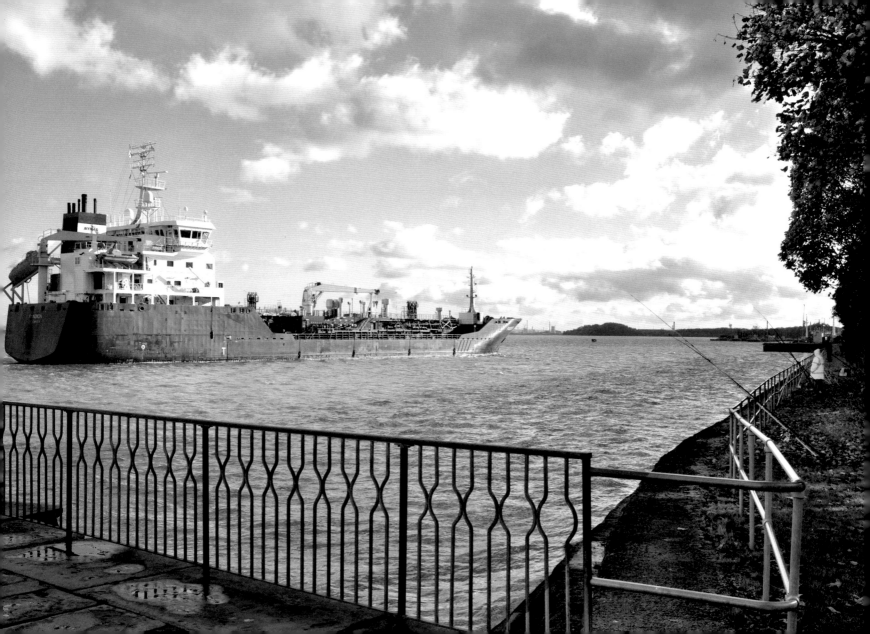

THE NATIONAL WATERWAYS MUSEUM AT ELLESMERE PORT

The town of Ellesmere Port sits on the river directly opposite John Lennon Airport and immediately to the east of Stanlow Refinery. Today the town is the home of the National Waterways Museum, which is situated on the former 7-acre site of the canal port. It is well worth a full day's visit and offers extensive indoor displays, boat trips and historic building tours, which explore the development of the canal systems across the country. Apart from its industrial attractions, the site is a haven for wildlife and birds such as pied wagtails, swans, coots, ducks, cormorants, moorhens, kingfishers and skylarks. The locks within the museum site are designated by English Heritage as Grade II listed buildings, as is the lighthouse at the entry of the canal and the lock-keeper's hut.

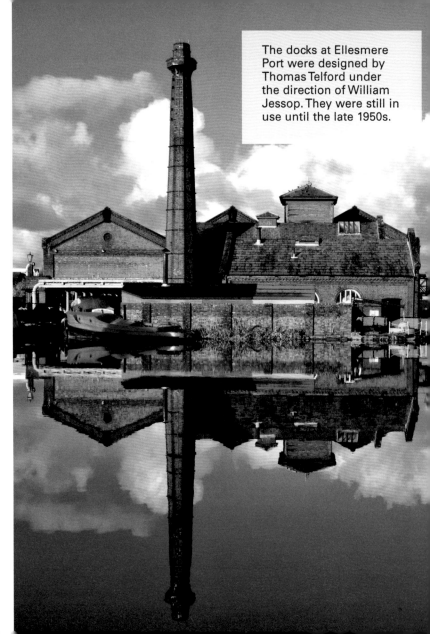

The docks at Ellesmere Port were designed by Thomas Telford under the direction of William Jessop. They were still in use until the late 1950s.

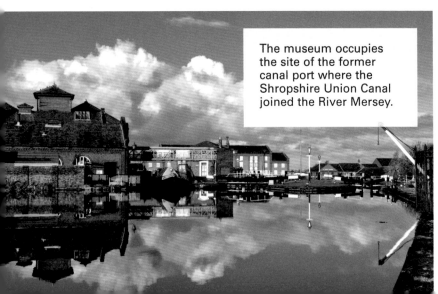

The museum occupies the site of the former canal port where the Shropshire Union Canal joined the River Mersey.

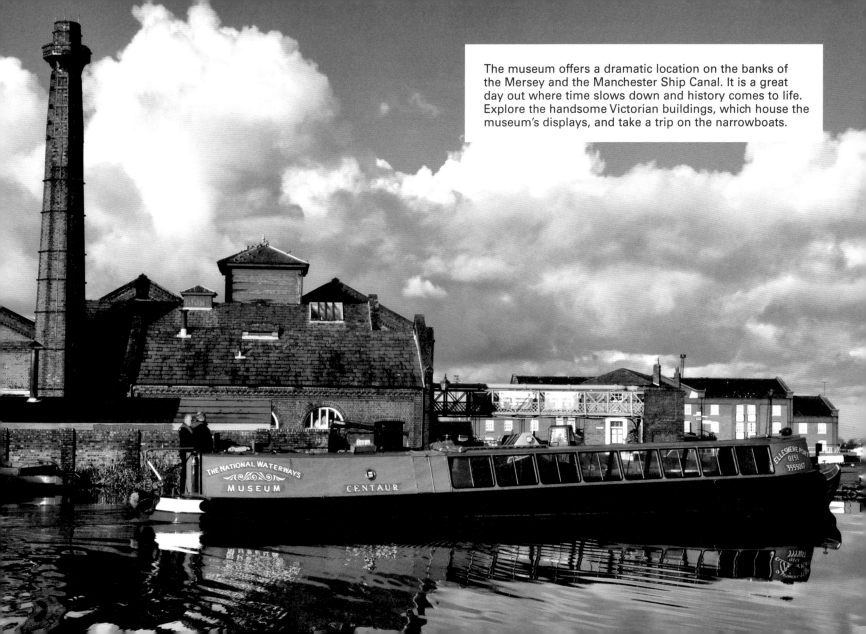

The museum offers a dramatic location on the banks of the Mersey and the Manchester Ship Canal. It is a great day out where time slows down and history comes to life. Explore the handsome Victorian buildings, which house the museum's displays, and take a trip on the narrowboats.

PORT SUNLIGHT

To the north of Eastham lies the model village of Port Sunlight, built by William Lever to accommodate the workers in 1888. He was keen to keep his workforce fit, healthy and happy in his soap factory. William supervised the work personally, employing nearly thirty different architects and overseeing the construction of 800 houses between 1899 and 1914. In addition to the houses, the village contained the Lady Lever Art Gallery, a cottage hospital, a concert hall, an open-air swimming pool, a church and a temperance hotel. Lever also introduced welfare schemes and educational opportunities for the workforce and their families. The village contains many Grade II listed buildings and was declared a conservation area in 1978.

The original Lever works was situated in Warrington, but by 1887 business was booming and a new site had to be found. They chose a stretch of flat, marshy ground by the side of the Mersey and constructed a much larger factory with a greater workforce. Their soap manufacturing business was a huge success, mainly because they were able to package the soap in small units and advertise it as a pure product. They replaced the fat content of the old soaps with palm oil, which, along with glycerine, gave the product a smoother and creamier feel.

For his workers, he provided entertainment, encouraged recreation and promoted the study of art, literature, science and music. It is interesting to note the impact of William Lever's vision on the health of the workforce. The infant mortality rate in Port Sunlight in 1909 was 70/1000 live births. Across the Mersey in Liverpool it was 140/1000, and the national average was 119/1000. Today the village stands in an oasis of tranquillity among the general heavy industrialisation and commercial business parks of the area. Approximately 250 houses still belong to the Port Sunlight Village Trust, with the others passing into private ownership when Unilever took the decision to put them up for general sale in the 1980s.

Above: To the north of Eastham lies the model village of Port Sunlight, built by William Lever to accommodate the workers. The village now contains many Grade II listed buildings and was declared a conservation area in 1978.

Opposite: The Lady Lever Art Gallery is seen in the background and the magnificent flowers that surround the analemmatic sundail shown in the foreground.

BIRKENHEAD FERRIES

Birkenhead is a town built on shipbuilding. In 1824, an ironworks was opened by William Laird and shipbuilding began in earnest in 1829. His business grew to eventually become the famous Cammell Laird shipyard. The north and south of the town are linked by ferry services running between Seacombe and Woodside. Seacombe lies to the north of the town and is the eastern side of Gerry Marsden's 'Ferry Cross The Mersey'. The ferries loop their way across the Mersey from the slightly more southern terminus at the Pier Head.

The ferries are big business now and offer more than just a means of getting from one side of the Mersey to the other. School groups can use the ferries for educational days out. You can hop between the U-Boat Story in Birkenhead, the Spaceport in Seacombe and the Beatles Story near Albert Dock. There are cruises too and sailings around the famous Mersey waterfront, or, for the more ambitious, a complete Manchester Ship Canal cruise of 6 hours, with return journey back from Manchester by bus. The boarding point of the Seacombe ferry marks a point where there has been a ferry crossing for over 600 years.

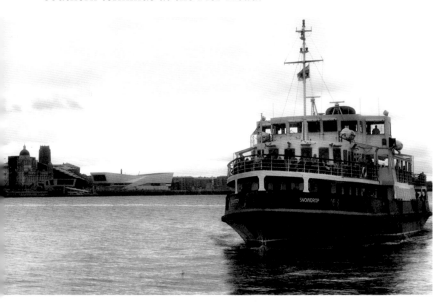

The Mersey ferry *Snowdrop,* preparing to dock at Seacombe, Birkenhead.

Above: The Mersey ferry at the Pier Head, Liverpool.

Opposite: Catch a 'Ferry Cross The Mersey' and you can become a 'Day Tripper', buying a 'Ticket To Ride' to take you 'Here, There and Everywhere'.

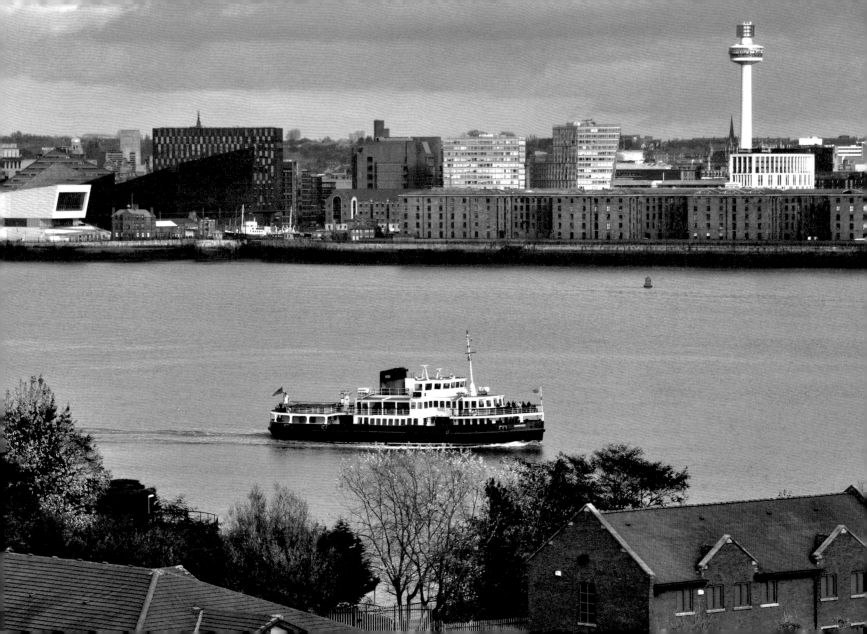

BIRKENHEAD PRIORY

Situated in Priory Street, Birkenhead Priory was the riverside home of Benedictine monks. Hamon de Masci, 3rd Baron of Dunham Massey, founded the priory in 1150, and it is the oldest standing building on Merseyside. The monks did not treat the priory as an isolated place of retreat and happily looked after travellers for over 400 years. They established the first ferry crossing between Liverpool and Birkenhead, which was operational up to the point of Dissolution in 1536. The ferry rights were granted to the monks by Edward II in 1318. With the revenue they built a house in what is now Water Street to store their corn, and the premises were also used by travellers for shelter if the weather was too bad and the ferry was unable to negotiate the hazardous crossing. The priory is consecrated as an Anglican church and is still used for services as well as a variety other community events.

The priory is a Grade II listed building, and contains many interesting pieces of Norman architecture. The tower, which has fine views north and south along the Mersey Estuary, is now dedicated as a memorial to the ninety-nine men lost in the 1939 disaster aboard the Laird's-built submarine, HMS *Thetis*. Within the Chapter House there is a small museum giving an overview of the history of the site. John Laird, co-founder of Cammell Lairds shipyard and Birkenhead's first Member of Parliament, is buried in the graveyard although, ironically, an expansion of the dock area adjacent to Cammell Laird resulted in the church losing a significant portion of the graveyard in the early 1960s. In 2005, the chapter house was restored and, in 2013, the priory was awarded nearly £400,000 from the Heritage Lottery Fund to transform the whole site into a multi-purpose community space.

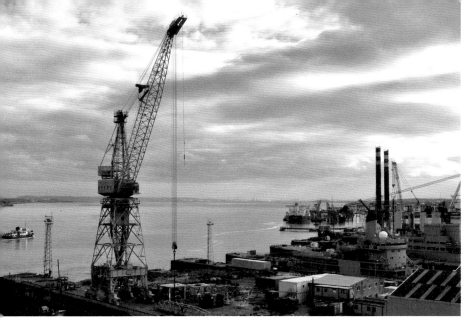

Above: Between 1829 and 1947, over 1,100 vessels of all kinds were launched from the Cammell Laird slipways into the River Mersey. The world's first steel ship, the *Ma Roberts,* was built there in 1858 for Dr Livingstone's Zambezi expedition.

Right: Touch the ancient sandstone walls of Birkenhead Priory and then look up at the towering cranes of the Cammell Laird shipyard next door.

Opposite: The monks of Birkenhead Priory looked after travellers for nearly 400 years and supervised the first regulated 'Ferry cross the Mersey', up until the Dissolution in 1536.

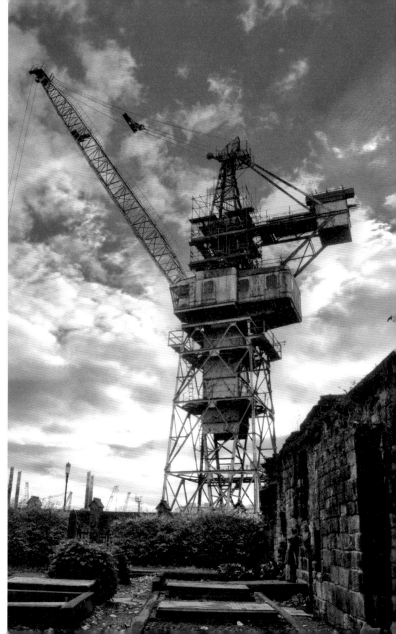

SEACOMBE TO EGREMONT

The stretch of riverside running from the Seacombe Ferry Terminal follows the river as it heads towards New Brighton and its exit into the Irish Sea. This area of Wallasey was originally part of Cheshire and had little in terms of population before the expansion of Birkenhead. By the early nineteenth century, the shoreline between Seacombe and Rock Point had started to become an attractive area to which affluent Liverpool merchants and sea captains could retire.

Development at Egremont began around this time, and gained pace with the introduction of steam ferries across the river. Sir John Tobin and Captain John Askew started Egremont Ferry in 1830. As this place had no name, it became known as 'Egremont' after the name of Askew's villa, which was named after his birthplace in Cumbria. A pier was built at Egremont in 1827 and was the longest on the Mersey a that time. Thousands of day-trippers tramped along it, as did bowler-hatted businessmen. The pier had to be scrapped in 1946 as it had been badly damaged and, as a result, the ferry ceased operating. Egremont's river frontage is part of the promenade that, under various names, runs as an unbroken traffic-free pedestrian route from Seacombe Ferry to New Brighton, and is the best place from which to view the panoramic skyline of Liverpool.

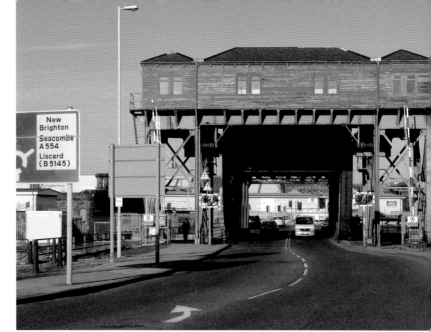

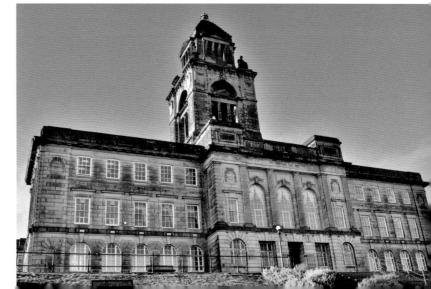

Above right: Tower Road Lift Bridge, Wallasey.

Right: Wallasey Town Hall standing proudly on the banks of the River Mersey.

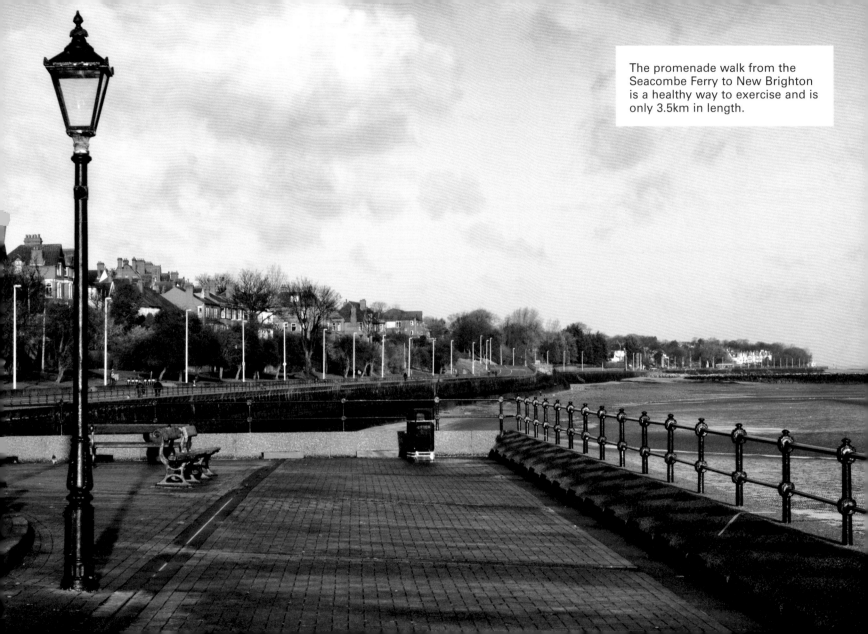

The promenade walk from the Seacombe Ferry to New Brighton is a healthy way to exercise and is only 3.5km in length.

NEW BRIGHTON

The seaside resort of New Brighton is located at the north-eastern tip of the Wirral Peninsula, with its sandy beaches lining the Mersey and facing the Irish Sea. The regeneration of the resort, with the Marine Point development at its centre, is again attracting the visitors and is looking towards a bright future. In 1830, James Atherton, a Liverpool merchant, purchased land at Rock Point. His vision was to develop the area as an elegant seaside resort for the wealthy gentry of the time – similar to Brighton, the splendid Regency resort on the South Coast of England.

New Brighton developed as a very popular resort during the late nineteenth century, serving Liverpool and many of the Lancashire industrial towns. In its heyday it had a pier, extensive promenade walks, an open-air bathing pool and a tower, larger than the one at Blackpool, with the famous Tower Ballroom. Although the tower was dismantled in 1921, the ballroom continued to thrive as a major venue until 1969, when it was destroyed by a fire. It was one of the largest and most ornate ballrooms in the world, and was one of The Beatles' favourite venues.

The River Mersey and the resort were described by the diarist Francis Kilvert in 1872 as 'crowded with vessels of all sorts moving up and down the river, ships, barques, brigs, brigantines, schooners, cutters, colliers, tugs, steamboats, lighters, "flats", everything from the huge emigrant liner steamship with four masts to the tiny sailing and rowing boat ... At New Brighton there are beautiful sands stretching for miles along the coast and the woods were green down to the salt water's edge. The sands were covered with middle class Liverpool folks and children out for a holiday.'

The famous Fort Perch Rock and New Brighton Lighthouse, formally the Perch Rock Lighthouse, have both been preserved and are now family owned. They are fabulous reminders of the past, sitting alongside the modern attractions and entertainment that New Brighton now offers to visitors and holidaymakers of all ages. There are good sandy beaches in New Brighton attracting many visitors. It also marks the end of the Mersey's journey from Stockport.

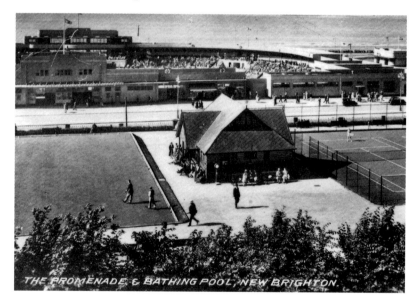

The promenade and bathing pool at the popular seaside resort of New Brighton in 1945.

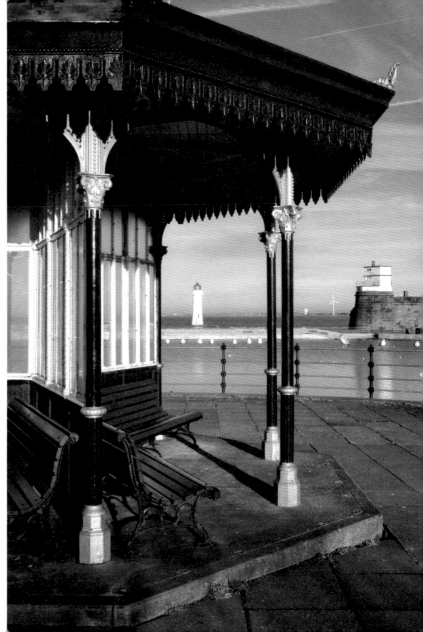

Above: The regeneration, with the Marine Point development at its centre, is attracting many visitors to the resort.

Right: The famous Fort Perch Rock, New Brighton Lighthouse, formally known as the Perch Rock Lighthouse, and the shelters are fabulous reminders of the past. They sit alongside the modern attractions and entertainments that New Brighton now offers to visitors and holidaymakers of all ages.

PERCH ROCK AND FORT

In the nineteenth century, the area around New Brighton developed as a strategic defensive point overlooking the growing Port of Liverpool. In 1829, Fort Perch Rock was built and, in 1858, Liscard Battery.

The drive to build Fort Perch Rock was instigated by Liverpool merchants concerned about a possible invasion by the French during the Napoleonic Wars. It was designed by Captain John Sikes Kitson of the Royal Engineers, and has room for 100 men plus officers. It had 18 guns, 16 of which were 32-pounders, and they faced the Rock Channel, which was the main entrance to the Mersey for shipping at that time. The ships passed 900 yards from the guns and the fort soon became known as the 'Little Gibraltar of the Mersey'.

The guns at Fort Perch Rock have actually only been fired twice in anger. During the First World War, a Norwegian ship entered Rock Channel, which had been declared closed under war orders. The vessel was fired on, but the gunners had the wrong elevation and the shell flew over the ship and landed in a garden at Hightown on the other side of the Mersey. The irate householder recovered the shell and presented it to the resident Battery Commander. It was later exhibited in the bar as 'a present from New Brighton'. The captain of the Norwegian vessel, when eventually challenged about his ship's use of the closed channel, replied that he did not know that a war had started! The fort was decommissioned by the War Office in 1956 and passed through various hands until it was sold into private ownership.

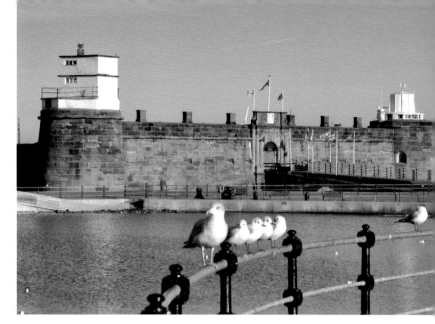

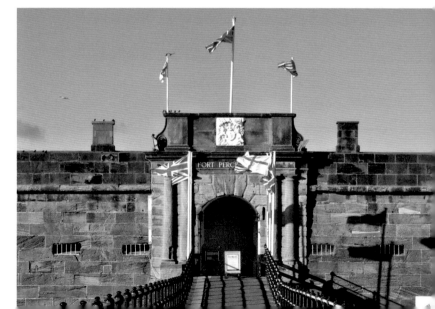

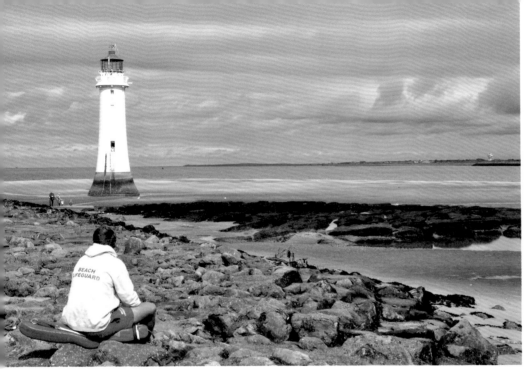

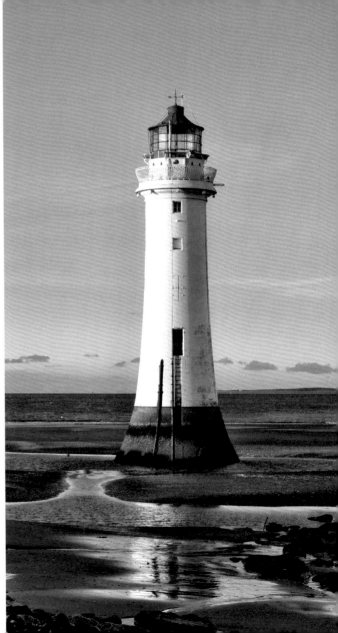

Above: Tony Murray, of the Wirral Beach Lifeguard Service, carefully watches the day-trippers on the beach.

Right: New Brighton Lighthouse, formally the Perch Rock Lighthouse, has been preserved and is now family owned.

Opposite above: Fort Perch Rock was built in 1829. The guns have actually only been fired twice in anger.

Opposite below: The ships passed only 900 yards from the guns of the fort and it soon became known as the 'Little Gibraltar of the Mersey'.

THE LIVERPOOL SHORELINE

As we leave the tranquil shoreline of Hale, a sharp turn in the river leads us into the boundaries of John Lennon Airport. Its tagline of 'Above Us Only Sky' heralds our arrival into the land of The Beatles and the rich social and cultural heritage of Liverpool's Mersey side of the river. From the Mersey Beat to the Mersey Poets, through *Blood Brothers*, *Shirley Valentine*, *Educating Rita*, *Brookside* and its *Boys from the Blackstuff*, Liverpool has forged its own legacy of poetry, music, literature and drama.

The city, of course, was built on the wealth of shipping trade, and between 1700 and 1800 was transformed from not much more than a fishing village into one of the busiest slave-trading ports in the world, and thence into a general trading port and city without rival in the nineteenth and twentieth centuries.

An estimated 15 million Africans were transported as slaves to the Americas between 1540 and 1850. Ships from Liverpool accounted for more than 40 per cent of the European slave trade. It laid the foundations for the city's growth and is no exaggeration to say that the Royal Liver Building, and other grand buildings along the waterfront, were built with the money generated from this traffic. The Merseyside Maritime Museum, with its gallery detailing the city's role in the trade, stands on the corner of Albert Dock. Built in 1841, the dock is next to the former entrance of Canning Dock – Liverpool's first dock to be used by the slave ships and today filled in and known as Canning Place. Two dry docks, used to repair slave ships from the 1750s until the end of the trade, are still used today by the Maritime Museum.

The International Slavery Museum, which opened in August 2007, is well worth a visit to explore this aspect of the Mersey's history. In March 2010, it welcomed its millionth visitor and is the only museum of its kind to look at aspects of historical and contemporary slavery as well as being an international hub for resources on human rights issues.

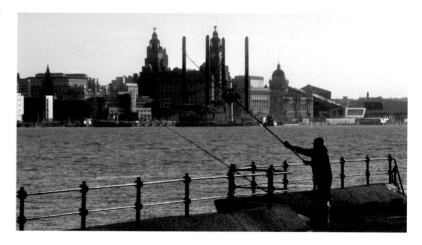

A local angler tries his luck in the deep, clean waters of the Mersey Estuary.

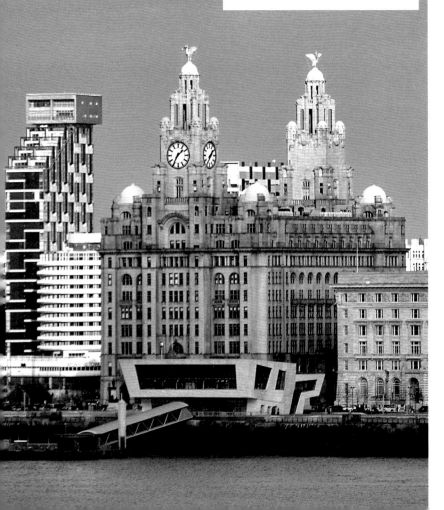

Overlooking the River Mersey and dominating one of the world's most famous waterfront skylines is the iconic symbol of Liverpool, the Royal Liver Building.

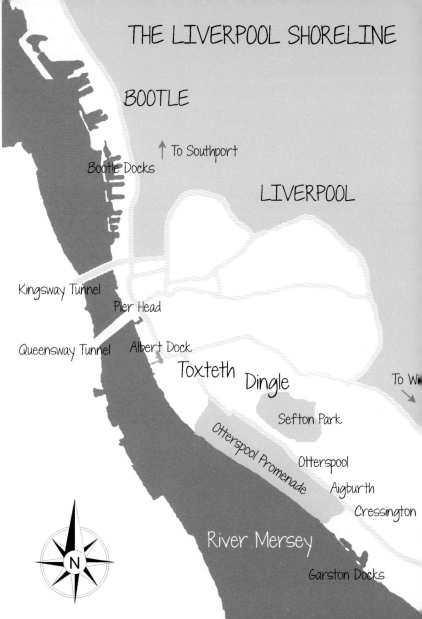

THE LIVERPOOL SHORELINE

BOOTLE

↑ To Southport

Bootle Docks

LIVERPOOL

Kingsway Tunnel

Pier Head

Queensway Tunnel

Albert Dock

Toxteth Dingle

To W

Sefton Park

Otterspool Promenade

Otterspool

Aigburth

Cressington

River Mersey

N

Garston Docks

GARSTON DOCKS

Sandwiched between the grounds of Speke Hall and the beginnings of Otterspool Promenade are the Garston Docks.

The first development around this area took place in the 1790s with the building of a salt works to refine salt mined from nearby areas in North Cheshire. Two tidal docks, Salt Dock and Rock Salt Dock, were constructed and salt was transported between Northwich and Garston until the works closed in 1865.

By the mid-eighteenth century, the railway had arrived and Garston Dock station marked the western terminus of the St Helens Canal & Railway Company, connecting with Widnes, Fiddlers Ferry and Warrington. With excellent rail links established, the company built the first major dock development at Garston, ensuring reliable access for shipping and providing a navigable base for the developing coal trade, which set up Garston as a rival to nearby Liverpool.

By 1902, Garston had become part of Liverpool and, around ten years later, the village was connected to the local tramway system. At the height of its commercial success, hundreds of people were employed at Garston Docks and on the miles of railways that serviced and connected them. The Victorian Garston became unrecognisable from the rural idyll that the village had once been. Like many industrial areas at the time of the Industrial Revolution, public health, hygiene and living conditions were extremely poor, and the working environment was dangerous and harsh. At one time, things were so bad that the London & North Western Railway company had to build a mortuary in Garston because the number of deaths on the docks and the railways was so high.

In 1912, Elders & Fyffes Ltd, the banana importers, moved from Manchester to Garston Docks, and by 1936 the docks at Garston and Liverpool were handling more bananas than any other port in the United Kingdom. The terminal at Garston developed special discharging elevators and railway trucks, and was capable, at its peak, of handling 12,000 bunches of bananas a day, discharging as many as seventy-two shiploads in a year. Elders & Fyffes owned twenty-two ships, eleven of which were lost through enemy action during the Second World War.

The port of Garston is still busy today handling container traffic and general cargo, including scrap metal, steel and cement.

Garston Docks sit on a navigable stretch of the Mersey, south of Liverpool, and handle large amounts of shipping and container traffic.

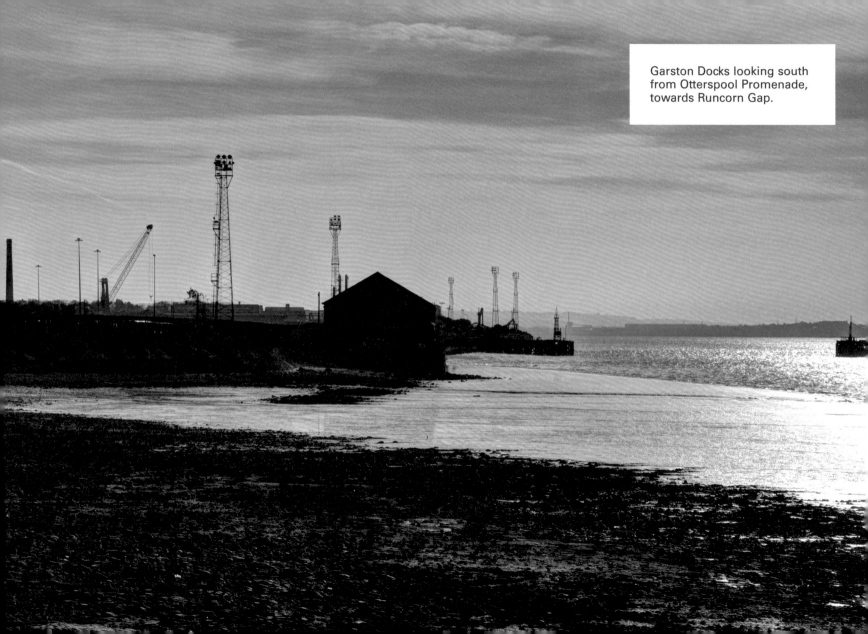

Garston Docks looking south from Otterspool Promenade, towards Runcorn Gap.

GRASSENDALE

Grassendale is a prestigious, almost entirely residential suburb, consisting of large, expensive and detached nineteenth-century villas. The area is particularly green, and the houses are set well back from the road. This district retains classic-style streetlamps, which give the area a traditional feel, and both Grassendale Park and Cressington Park were designated as Conservation Areas on 13 November 1968. The ward, which contains both parks and the housing, is called Cressington. Grassendale and Cressington Parks are nineteenth-century gated private estates, built for wealthy Liverpool merchants in what was then open country. They were 'carriage folk', who had the means to travel to and from the city centre.

Turn off the busy dual carriageway of Aigburth Road, through the ornate sandstone gates and past the elegant sandstone lodge house, and you enter a quiet enclave of Victorian mansions laid out in early to mid-nineteenth century style along carriageways leading to a splendid riverside esplanade. Grassendale and Cressington Parks were completed in 1845 and 1846 respectively and were the second and third of Aigburth's gated riverside housing developments (Fulwood Park, which has the largest and most impressive houses, was the first). The residents even had their own railway station when the Cheshire Lines branch opened in 1861. Today, access to the station by non-residents remains a concession granted by the Trustees.

Above right: A magnificent Victorian villa on Grassendale Esplanade, looking out across the Mersey.

Grassendale Park was designated as a Conservation Area on 13 November 1968. The district retains the classic-style streetlamps, which give the area a traditional feel.

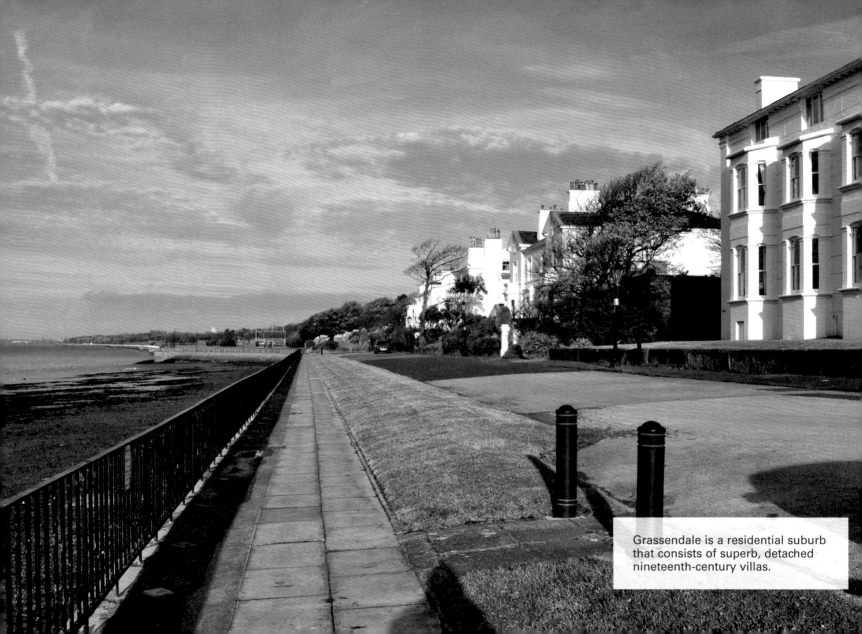

Grassendale is a residential suburb that consists of superb, detached nineteenth-century villas.

OTTERSPOOL

A short distance from Speke Hall is the start of a 3-mile riverside walk, which takes walkers and cyclists from the edge of Garston Docks to the outskirts of the city and the southern reaches of the Liverpool Docks. The trail starts with a short journey down Cressington Esplanade, a fine road of impressive Victorian villas set in their own grounds, and on to the Otterspool Promenade. The riverside promenade was opened to the public on 7 July 1950 and contained putting and bowling greens and a café built on the site of Otterspool House. The promenade was constructed by landscaping a site that had been used for the disposal of household waste and rubble left over from the construction of the Queensway Tunnel.

Before the Industrial Revolution, fishermen's nets and cottages stretched along this part of the Mersey. The river was famous for its varieties of fish, which included salmon, codling, whiting, fluke, sole and shrimp. One of the first industrial businesses along the stretch of river was a snuff mill, which was erected along with workers' cottages. In 1812, local entrepreneur John Moss turned the snuff mill into an oil mill and constructed Otterspool House. His family remained in residence there until the 1890s.

The construction of the river wall was actually completed much earlier than the promenade itself. Plans to construct the wall were submitted in the late 1920s, and involved reclaiming land 200 yards wide along the length of the foreshore. The work commenced in 1929, eventually being completed some three years later. The council then had to consider a plan for filling in the space between the wall and the ground, which had been excavated during its construction. It came up with the idea of using the space as a temporary tip and provided enough space to meet the bulk of Liverpool's requirements until the construction of the promenade in 1950. The saving on disposal and incineration costs meant that the council saved enough money to offset the original cost of the reconstruction of the whole area.

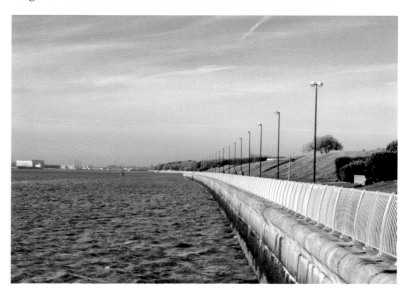

Above: The construction of the river wall commenced in 1929 and was completed some three years later.

Opposite: The open space, the fresh air and the magnificent views across the Mersey will make you forget that you are on the outskirts of a large city.

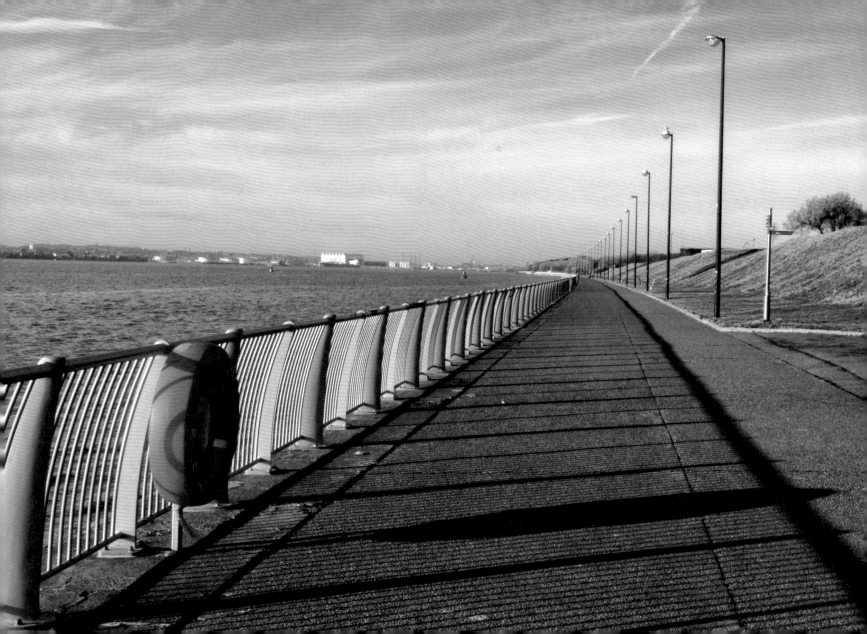

DINGLE

Leaving the leafy suburbs of Grassendale and Otterspool, the river meets the start of the Liverpool Dockland areas of Dingle and Toxteth. Dingle is named after Dingle Brook, which flowed out into the Mersey at a narrow bay called Knott's Hole at the end of Dingle Lane. This has all disappeared now. At the time, Dingle was a pleasant rural area of grand houses, extensive gardens, freshwater streams and a clean, sandy beach. Today, the area has tightly packed terraced streets, typical of a northern industrial suburb.

The area was the home to a number of famous Liverpudlians, including 1960s pop stars Gerry Marsden and Billy Fury. Richard Starkey, better known as Ringo Starr, was born at No. 9 Madryn Street before his family moved a minute's walk away to Admiral Grove. He was still living there when he joined The Beatles, and all four members attended his twenty-first birthday party there in 1961. When the house in Madryn Street came under threat of demolition, a proposal was put forward to take the house down brick by brick and rebuild it as a centrepiece of the new Museum of Liverpool.

The eleven streets near Princes Park are nicknamed 'The Welsh Streets'. They were built around the late 1800s by skilled Welsh workers who had moved into the area, settled, and built a large percentage of buildings around Liverpool in the late nineteenth and early twentieth centuries. The streets were named after Welsh towns, valleys and villages, and have distinctive yellow brick and red stone frontages with ornate carved stone lintels across the window and doors. At the time of writing, people living in Liverpool's 'Welsh Streets' have backed plans to transform the area by building new homes and refurbishing some existing properties.

Above: No. 9 Madryn Street, Dingle, once the home of Ringo Starr. The wire mesh on the door and window has been signed by many people from all over the world.

Opposite: A row of the colourful houses along Madryn Street.

Inset: The Madryn street nameplate.

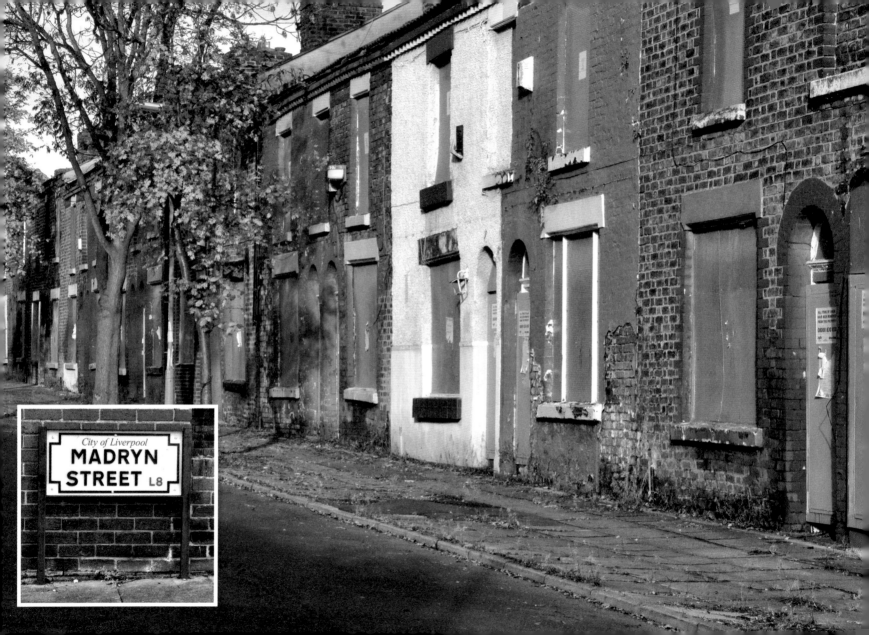

THE SOUTHERN DOCK AREA

The southern dock area of Liverpool sits in and around the Albert Dock complex. The main docks are interconnected, with Salthouse Dock connecting with Canning Dock to the north, Wapping Dock to the south and Albert Dock to the west. Designed by Thomas Steers, the complex was completed after his death by Henry Berry and opened in 1753. As indicated by its name, Salthouse Dock was an important terminal for the salt industry, securing a Liverpool base for the refining of rock salt brought from Cheshire and providing for its onward transportation. When Albert Dock opened in 1846, vessels were able to unload their cargo and then move on to the Salthouse Dock for reloading. An interesting feature, still there today, is the stone gable and arch entrance from a warehouse built by Jesse Hartley, which survives at the south-east corner of the dock.

Canning Dock was opened in 1737, and was officially named after the Liverpool MP, George Canning, in 1832. The dock has its place in Liverpool history as it initially served ships involved in the transatlantic slave trade. To its east is the site of Old Dock, which was built in 1709 and was the world's first enclosed commercial dock.

Wapping Dock was opened in 1852. It was named after the road that runs along its side, and also gave its name to the Wapping Tunnel. Along its eastern side is a large brick warehouse built in 1856 and also designed by Jesse Hartley. It is of similar architectural style to the warehouses surrounding the nearby Albert Dock. When it was built it was 232 metres long and consisted of five separate sections. However, the dock area was badly bombed in the Blitz of May 1941, and the damaged southernmost section was not rebuilt. Today, only the supporting columns are left, but the remainder of the building continued in commercial use, even after the dock closed in 1972. The warehouse was restored and converted into residential apartments in 1988 and is a Grade II* building.

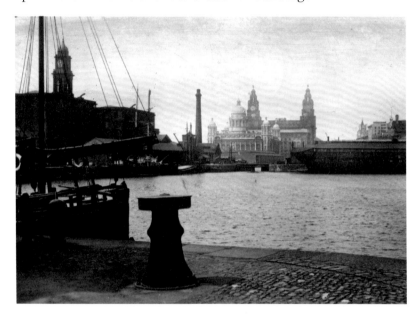

Above: Salthouse Dock, seen here in 1928, was opened in 1753 and designed by Thomas Steers.

Opposite: Salthouse Dock and quay was an important transit terminal for the salt industry.

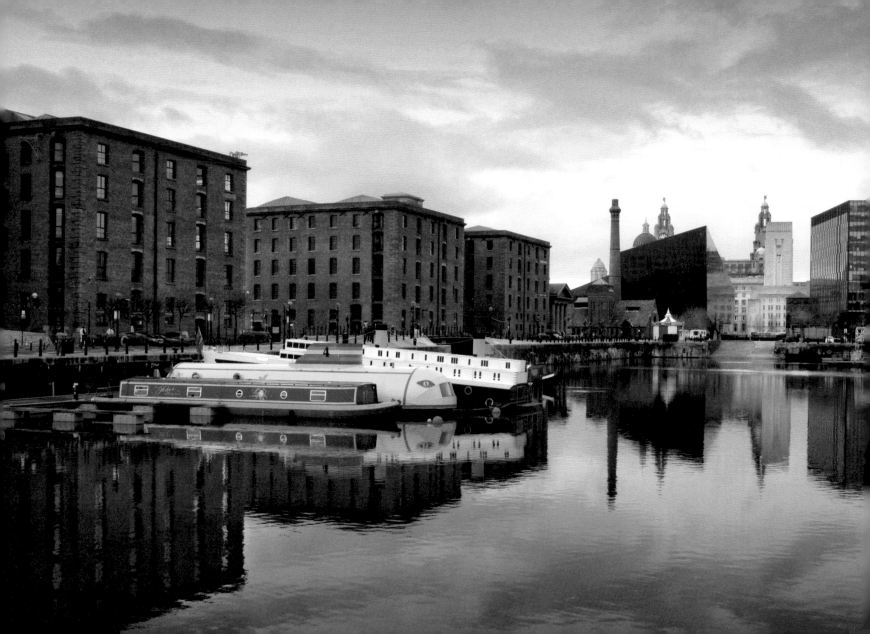

THE MERSEY TUNNELS

The Mersey Tunnels connect Liverpool with the Wirral Peninsula. There are three different tunnels, two being for motor traffic and the other carrying the oldest underground railway line outside London. The Mersey Railway Tunnel is by far the oldest of the three and was operational by 1886. The two road tunnels followed, with the Queensway Tunnel opening in 1934 and the Kingsway Tunnel in 1971. The Railway Tunnel and Queensway Tunnel connect Liverpool with Birkenhead, while the Kingsway Tunnel takes motorists to Wallasey.

Interested parties from Liverpool, Birkenhead, Bootle and Wallasey formed a committee in 1922 to draw up plans for the first road crossing. Ferries and the railway could cope with the demand from passengers to cross the Mersey, but they could not cope with the demand for goods traffic. There were also ambitious plans to construct a tramway in the bottom half of the tunnel, with the construction work aimed at reducing unemployment in the city.

At the time, there was great debate as to whether the crossing should be a bridge or a tunnel, but it was thought that a tunnel would be much cheaper to build and maintain. Other considerations were the fear that a bridge could be damaged or block the river if there was a war, and also that any bridge supports on the riverbed might cause silting. The tunnel entrances, tollbooths and ventilation building exteriors were designed by architect Herbert James Rowse, who is frequently credited with the whole civil engineering project but did not have overall responsibility for the complete works. During construction, more than a million tons of rock, gravel and clay were excavated, and some of it was put to good use in the construction of Otterspool Promenade a few miles to the south. The plan for the original tunnel was so ambitious that, at the time, it would have been the largest underwater tunnel ever built. Both tunnels are today Grade II listed buildings.

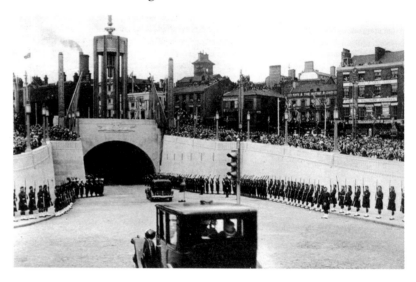

Above: The Queensway Tunnel was opened on 18 July 1934 by HM King George V in a ceremony reportedly watched by thousands of people.

Opposite: The entrance to Queensway Tunnel as seen today from St John's Gardens, in front of St George's Hall.

THE ALBERT DOCK

Designed by Jesse Hartley and Philip Hardwick, the Albert Dock is a complex of dock buildings and warehouses that stand close to Liverpool's Pier Head. It was opened in 1846 and was completely free from any wooden structures, being constructed entirely from cast iron, brick and stone. It was the first building in Britain of its kind and, as a result of its construction, was the first completely fireproof warehouse system in the world. At the time of its opening, the Albert Dock was considered a revolutionary docking system because goods arriving by sea could transferred directly from ship to warehouse.

Albert Dock has been part of Liverpool's commercial trade for over 160 years and remains a key attraction for visitors to Liverpool's waterfront. Today, it forms part of the modern attractions for visitors while maintaining its heritage through the preservation of many of its key structures. In fact, the area around the dock contains the largest group of Grade I listed buildings in the UK. Attractions that have been incorporated into the complex include the Liverpool Tate, the Merseyside Maritime Museum, the International Slavery Museum and the Beatles Story, where tourists are invited to relive the exciting life, times, culture and music of The Beatles. The area has a wide range of bars and restaurants. It is a place where old and new mingles comfortably and the family attractions of the day merge seamlessly into a vibrant, exciting nightlife. The modernised dock was officially reopened by HRH Prince Charles on 24 May 1988, and has since gone on to win a string of awards for the unique atmosphere of the area, and the quality and diversity of its attractions.

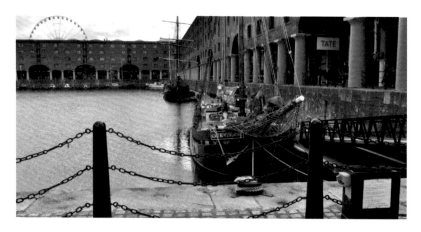

The huge, cast-iron columns line the Albert Dock quayside. The large ships could be loaded and unloaded directly from the warehouses.

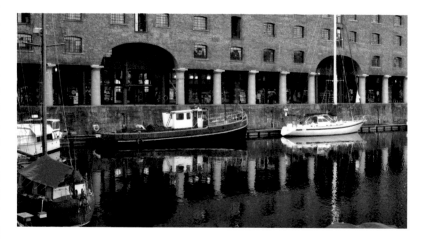

Albert Dock was considered a state-of-the-art fireproof docking system when opened in 1846 by Prince Albert.

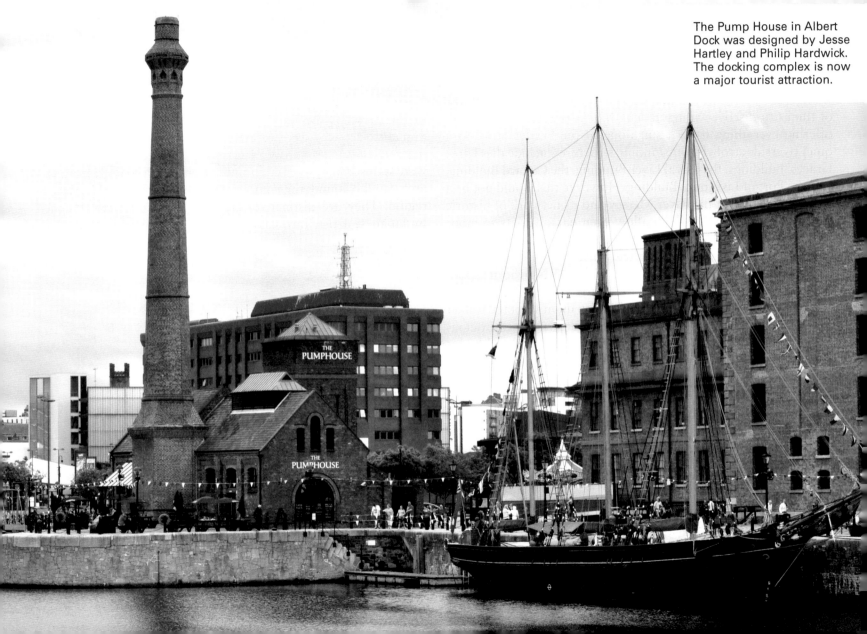

The Pump House in Albert Dock was designed by Jesse Hartley and Philip Hardwick. The docking complex is now a major tourist attraction.

LIVERPOOL WATERFRONT

Liverpool waterfront is a great place to visit with a whole host of things to discover along its length. It is diverse in its appeal, offering everything from a singalong in the Beatles Story to a quiet riverside stroll. Its outstanding structures include the 'Three Graces' buildings: the Royal Liver Building, the Cunard Building, and the Port of Liverpool Building. However, this would not be a waterfront without the River Mersey and its network of historic docks and canal links, which allow even narrowboats to moor right in the heart of Liverpool. The many statues and landmarks along the front help make this a truly historic place to visit.

There's the statue to Captain F. J. Walker, RN, who it is said did more than any other man at sea to win the Battle of the Atlantic. Winston Churchill heaped praise upon Captain Walker for his heroics throughout one of the most drawn-out and vicious encounters of the Second World War. He was considered by his contemporaries to be one of the greatest fighting captains in the Royal Navy and sank twenty U-boats over the course of the war.

One of the most interesting memorials is the one dedicated to the members of the *Titanic*'s engine room, which can be found close to the water's edge in St Nicholas Place. This huge granite monument marks Liverpool's strong association with the ill-fated liner that sank on 15 April 1912, after striking an iceberg in the North Atlantic. The RMS *Titanic* was owned by the White Star Line, and Liverpool was its port of registry – the words 'Titanic, Liverpool' clearly visible on the stern of the ship. The memorial contains a list of crew members from the ship, remembering their heroics as they stayed at their posts, supplying the stricken liner with electricity and other amenities for as long as possible. The monument was one of the first in the United Kingdom dedicated to ordinary working people.

More unusual sculptures can be found along the waterfront in the guise of the Lambananas. These individually designed miniature replicas were created for Liverpool's celebrations to mark its status as European Capital of Culture in 2008. They were sponsored by local community organisations and businesses and can be found throughout the Liverpool and Merseyside region. They are distinctive and colourful and were designed by Japanese artist, Taro Chiezo.

'The Three Graces' are shown standing proudly in front of the Pier Head. The Royal Liver Building, built between 1908 and 1911, is a Grade I listed building. The Cunard Building, constructed between 1914 and 1916, is a Grade II* listed building and the Port of Liverpool Building, built from 1903 to 1907, is also Grade II* listed.

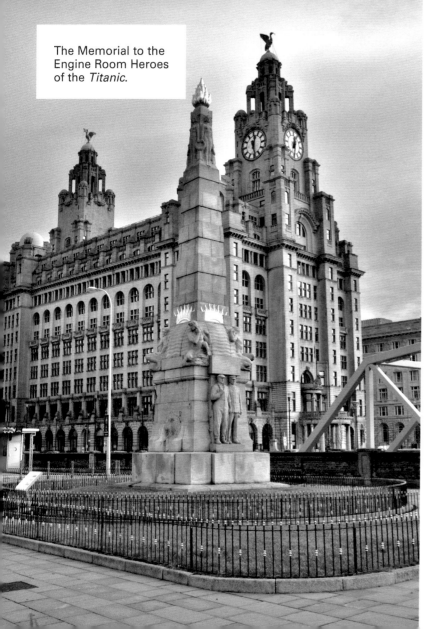

The Memorial to the Engine Room Heroes of the *Titanic*.

The 'music' mini lambanana watching the river.

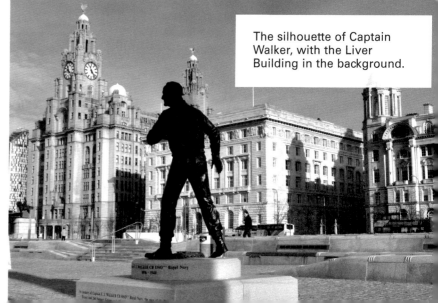

The silhouette of Captain Walker, with the Liver Building in the background.

LIVERPOOL AND TOURISM

Liverpool is now the ideal destination to visit and explore, and visitors are attracted by its theatre, music and sporting events, as well as the heritage of the city and its cluster of museums and art galleries. Liverpool is well known for its musical heritage, the history of its buildings, industry and transportation, and also the developments relating to its public health and social reform. Its status as a vibrant trading port has contributed to its diversity of population, drawn from a wide range of different cultures and religions.

The book of *Guinness World Records* labels Liverpool as the 'World Capital City of Pop', and its artists have produced more No. 1 singles than any other city. Its most popular artists include The Beatles, Gerry and the Pacemakers, Cilla Black and Billy Fury from the Merseybeat era, and other more modern stars such as Echo and the Bunnymen and Frankie Goes to Hollywood. The history of popular culture is woven into Liverpool's fabric and is a huge tourist magnet, contributing significantly to the city's economy. In 2007, the city celebrated its 800th anniversary and in 2008 held the title of European Capital of Culture, together with Stavanger in Norway.

Many of Liverpool's building are regarded as the finest examples in the world of their respective styles, and several areas of the city centre were granted World Heritage status by UNESCO in 2004.

Of course, Liverpool also has a great sporting identity. The city is home to two Premier League football clubs, Liverpool and Everton, and the world-famous Grand National horse race takes place annually at Aintree on the outskirts of the city.

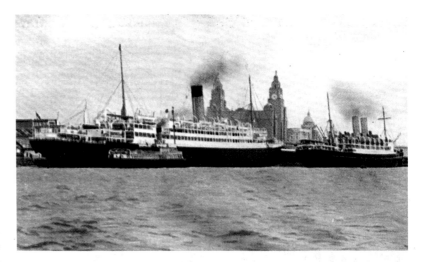

Above: Atlantic liners could always be seen at the Prince's Landing Stage when the Mersey was a major route to the North Atlantic.

Right: George 'The Busker', entertaining the visitors at Albert Dock.

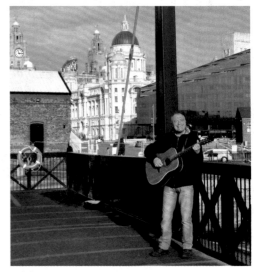

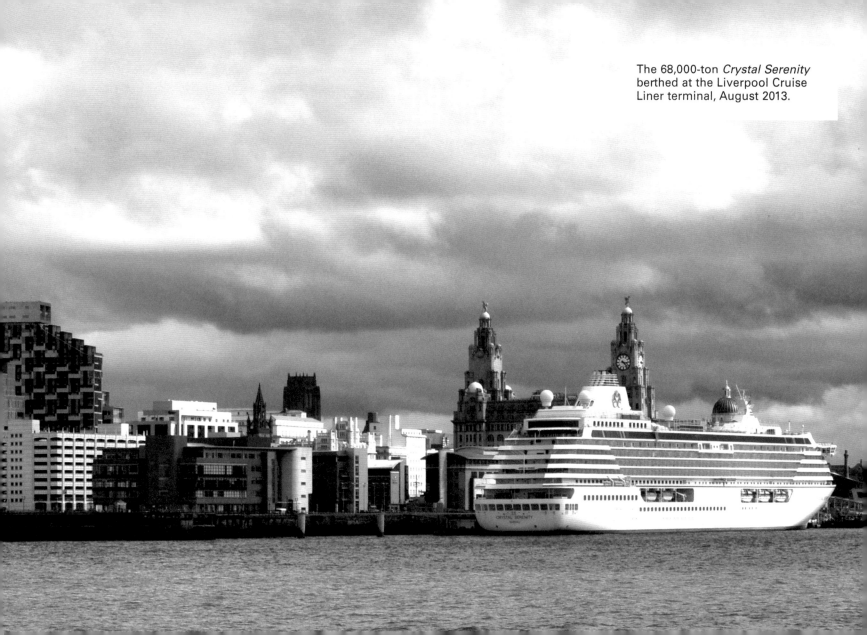

The 68,000-ton *Crystal Serenity* berthed at the Liverpool Cruise Liner terminal, August 2013.

THE NORTHERN DOCK AREA

By the end of the nineteenth century, the northern docks had been constructed along the whole of the riverfront as far as Seaforth Sands. The population of Bootle grew significantly during this period due to the attraction of regular work on the docks. The skilled workers lived in terraced houses in the east of the town, while the casual dock labourers lived in cramped dwellings near the dockside. There are still many remnants of the old glory days of the docks situated along its length. Perhaps one of the most interesting is the Victorian red-brick pump house, which contained the steam engine to operate the locks at Langton Dock. The driving Atlantic rains have left their mark on the building.

Salisbury Dock is connected to Nelson Dock to the north and Trafalgar Dock to the south. Its purpose was as a half-tide dock, which was connected directly to the river via two lock entrances. The locks provided access between the Mersey and the Leeds & Liverpool Canal and were the principal hub for coastal and barge traffic during the mid-twentieth century. The Victoria Tower was constructed between 1847 and 1848 to commemorate the opening of the dock. It is a Grade II-listed Gothic-style clock and bell tower. The 'Docker's Clock', as it was once called, acted as an aid to ships by giving them the correct time and any meteorological changes, such as high tide and fog by ringing the bell. It was designed by Jesse Hartley and was constructed from irregular shaped blocks of grey granite. The imposing tower has a central hexagonal column onto which the tower's six clocks are attached.

Seaforth Dock is a purpose-built dock and container terminal. It is situated at the northern end of the dock system and is connected to Gladstone Dock to the south, which provides maritime access to the dock from the Mersey via its lock entrance. The dock was the largest built in the United Kingdom for some time, with 10,000 feet of quay and a depth of 50 feet. It also had the world's largest lock gates. Six wind turbines have been installed along the river wall.

Above: The hexagonal Victoria Tower, shown here with the impressive old tobacco warehouse at Stanley Dock, stands at the entrance to Salisbury Dock.

Opposite: The 'King's Pipe' is situated at Stanley Dock tobacco warehouse on Regent Road. If tax was not paid on the tobacco it was burnt.

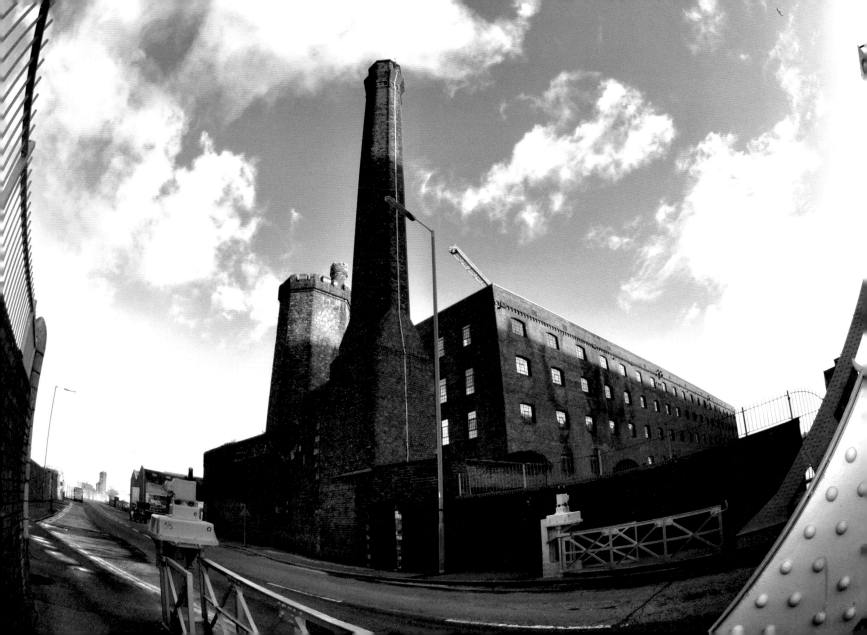

THE BEATLES

Our journey along the Mersey has taken us through large towns and villages, quiet rural areas, peaceful countryside and pockets of industrialisation. Arriving at Liverpool, it would be an incomplete journey to not mention the group from Liverpool that forever cemented the name of the river in popular culture.

The phenomenon that was to become the The Beatles started in 1957 when Paul auditioned for the guitarist's position in a skiffle group called the Quarrymen. The band was led by John and two more musicians were brought in, George and Stuart (Sutcliffe). The band went through two name changes during this time – Johnny and the Moondogs and then the Silver Beetles – it was finally changed to The Beatles (with an 'a'!) in 1960. A full time drummer was recruited, Pete (Best), and the band secured a residency in Hamburg. The musical and lyrical partnership of Lennon and McCartney was beginning to evolve and the next couple of years, from having to leave Hamburg to recording their first No. 1, 'From Me To You', were to be turbulent, changeable and then finally very rewarding times. During this period, Brian Epstein became their manager, Stuart died, record producer George Martin signed them to the Parlophone record label, Pete was sacked, Ringo joined and they broke into the charts with their debut single, 'Love Me Do'. The major moment in the career of The Beatles, and of music across the world, came on 13 February 1963, when they appeared on *Thank Your Lucky Stars* to promote 'Please Please Me'. The show was seen by over 6 million viewers and Beatlemania had hit the nation. In 1964, they appeared on Ed Sullivan's top-rated television show and America was conquered.

Some of the iconic places from their story are still present in the city. In Mathew Street, The Cavern is still there, albeit on the opposite side of the street now. On the original site of the club is a wall bearing bricks with the inscriptions of all the known bands that played on the original stage. A statue of John Lennon leans casually outside the Cavern Pub and, in nearby Stanley Street, is Tommy Steele's poignant sculpture of Eleanor Rigby. The homes of John Lennon and Paul McCartney are now preserved by The National Trust and can be visited by on a guided tour from Speke Hall. The buses still run down Penny Lane and the entrance to Strawberry Fields is still there on Beaconsfield Road. A short distance away, across Calderstones Park, is Calderstones School, formally Quarry Bank High School, where John Lennon formed the Quarrymen in 1956. The full story of their childhoods, how they met, and how they shaped the music of a generation is told in detail at the Beatles Story, situated in Albert Dock.

Above left: The 'Imagine' video was produced in John and Yoko's 'White Room'. The room is recreated at the Beatles Story exhibition.

Above right: The bronze statue of John Lennon stands in Mathew Street, Liverpool. John Lennon was born on 9 October 1940 in Liverpool, and died on 8 December 1980, in New York.

Right: The Cavern, the most famous club in the world, is buried deep beneath Mathew Street in Liverpool's city centre. The stage is shown in the Beatles Story exhibition.

Left: The 'Fab Four' appear in many guises throughout the city. Beatles mementos have been on sale for more than fifty years.

CONCLUSION

It has been a great experience for us to photograph the river and its tributaries along their entire length of over 70 miles. We hope the photographs capture the diversity of its different parts and might inspire you to visit some of the places in the book. What we have found on our travels is that, whether its the peace and tranquillity of its sleepy meanderings through the South Manchester suburbs, its still, almost unnoticed journeys though Woolston Eyes and Paddington Meadows, the windswept beauty of Fiddlers Ferry and Widnes and Runcorn promenades, the walks along the bank of the Wirral, or splendour and history of Liverpool's waterfront, the river is loved by those who live along its banks or are drawn to walk, run, cycle or sail along its course. Along its length there is a real feeling of regeneration and a return to the days when people paddled or swam in its clean, fresh waters. The last twenty years have almost seen the river recover from over a century of misuse. The next twenty should be an exciting chapter in its journey towards full environmental regeneration.

Ian has regularly led walks along the Mersey's tributary rivers; the Goyt, Tame, Sett and Etherow. Phil spent his childhood in West Bank and Widnes. This is their second publication for Amberley, the first being *The Four Heatons Through Time*, 2013.

Ian Littlechilds & Phil Page

ACKNOWLEDGEMENTS

We would like to thank the following people and organisations, whose help and knowledge have been invaluable in compiling sections of the book.

Betty and Ray Jones; Jack Rowley, Marketing Assistant, the Beatles Story, Liverpool; Tony Murray of the Wirral Beach Lifeguard Service; George the Busker from Albert Dock; Violet Baxter, former landlady of The Bridge Hotel, West Bank, Widnes; Salford Local History Library for providing the photograph of Bob's Ferry.

We would also like to acknowledge the following publications, which were valuable reference sources when researching aspects of the Mersey.

Freethy, Ron, *Riverside Rambles Along The Mersey*, Sigma Press, 2004
Freethy, Ron, *The River Mersey*, The Laverham Press Ltd, 1985
Jenkins, Fiona, *Images Of West Bank*, West Bank Heritage Project, 2005
Palmer, William T., *The River Mersey*, Robert Hale Ltd, 1944
Wirral Peninsula, *Official Visitor Guide*, 2013
Wray, Ian, *Mersey: The River That Changed The World*, The Bluecoat Press, 2007

Beatles Story Photographs reproduced by kind permission of the Beatles Story, Albert Dock, Liverpool. All image rights are held by the Beatles Story.